W9-CUI-207

IMAGES
of America

TOMBSTONE

IMAGES
of America

TOMBSTONE

Jane Eppinga

ARCADIA
PUBLISHING

Published by Arcadia Publishing
Charleston, South Carolina

Printed in the United States of America

Library of Congress Catalog Card Number: 2003105835

For all general information contact Arcadia Publishing at:
Telephone 843-853-2070
Fax 843-853-0044
E-Mail sales@arcadiapublishing.com
For customer service and orders:
Toll-Free 1-888-313-2665

Visit us on the Internet at www.arcadiapublishing.com

CONTENTS

Acknowledgments 6

Introduction 7

1. Fort Huachuca and the Apaches 9

2. The Discovery of Silver 19

3. The Growth of Tombstone 29

4. Gunfight at the O.K. Corral 45

5. Tombstone's Entertainment Tonight 61

6. The Law and the Outlaw 79

7. Tombstone's Boothill Cemetery 93

8. Helldorado 103

9. Tombstone and the Movies 117

10. Let's Visit Tombstone 125

ACKNOWLEDGMENTS

The work of a book is never entirely the work of one person and so it is with *Images of America: Tombstone*. Many individuals have helped me. Glenn Boyer, who has extensively interviewed the Earp family descendants, shared his photographs and knowledge. Ben T. Traywick, known locally as Tombstone's historian, took time to talk to me and share his photographs. Hal Edwards gave freely of his research and photographs of the Burt Alvord affair. James Finley, Fort Huachuca's historian, found many interesting old military photographs for this book. Douglas Brown of Groton School supplied the information on the Reverend Endicott Peabody and St. Paul's Episcopal Church. Claire Brandt from Saturday Matinee worked miracles in getting old-time Tombstone movie photos. Organizations that have contributed to this work are the National Archives in Washington D.C., the Library of Congress, the Arizona Historical Society, the Arizona State Archives, and the Tombstone State Park. Thanks also to two venerable California institutions: the Bancroft Library at Berkeley and the Huntington Library. No book sees the light of day without a publisher and an editor such as Arcadia and Christine Riley and Arcadia staff Mick Crouch, Sarah Wassell, Sarah San Angelo, and Larry James. Finally the biggest contributors are those pioneers who left their stories and mark on the Tombstone, "The Town Too Tough to Die."

INTRODUCTION

Tombstone owes its beginning to Ed Schieffelin, who prospected the nearby hills. From nearby Fort Huachuca, Schieffelin told a soldier that the mountains' rich colors looked very promising for mineral wealth. The soldier sneered, "All you'll find in those hills is your tombstone." In February 1878, Schieffelin found a vein of rich silver ore and registered two claims as the "Tombstone" and the "Graveyard." He took an ore sampling to his brother Al in Signal, Arizona, and they returned to Tombstone with assayer Richard K. Gird who had found the ore to be very rich in silver. Along the way, Ed located two more silver claims that he registered as the "Lucky Cuss" and the "Toughnut."

Although Tombstone acquired a reputation as a hell-raising town, it also had four churches, a school, two banks, several newspapers, including the *Epitaph*, the *Nugget*, and the *Prospector*, an opera house, the Bird Cage Theatre, and Schiefflin Hall, which provided legitimate theater and a meeting hall for the Masonic Lodge.

Tombstone, best remembered for the notorious gunfight at the O.K. Corral, had a population of 10,000 in 1881. A feud between the Earp brothers and Doc Holliday on one side and the Clantons and McLaurys on the other side culminated in the famous gunfight on October 26, 1881. Just who shot first is still a matter of great historical debate. What is known is that in less than 30 seconds three men lay dead and three more were wounded. Virgil Earp had been shot in the leg and his brother Morgan Earp shot through both shoulders. Only Wyatt Earp survived the fight unwounded.

As Tombstone's population grew, so did its political power. In 1881, the Arizona legislature established Cochise County with Tombstone as the county seat. Built in 1882 at a cost of $50,000, the Cochise County Courthouse is a stylish building that served as a symbol of law and stability in those turbulent times, with offices for the sheriff, recorder, treasurer, and the board of supervisors, as well as a jail and a courtroom. Sheriff John Slaughter, a local cattleman, took no prisoners and cleared the county of outlaws. Many colorful characters made Tombstone a special place: Johnny Ringo, Johnny Behind the Deuce, Curly Bill Brocius, Three-Fingered Jack Dunlap, and Fatty Ryan.

Today the entire town of Tombstone is preserved by the National Park Service as the Tombstone Historic District. There, visitors can see the Crystal Palace Saloon, which once served as the office of City Marshal Virgil Earp, as well as the famous O.K. Corral. Tourists can stroll along Allen Street, once full of bars and bordellos. The original Cochise County Courthouse features exhibits and artifacts that tell of Tombstone's colorful past. Boothill is the place where many "died with their boots on." The Bird Cage Theatre was the site for the composing of the song "She's Only a Bird in a Gilded Cage."

One

FORT HUACHUCA AND THE APACHES

Both Fort Huachuca and the Apaches of southern Arizona are relevant to Tombstone's story, for without either one there might not have been the discovery of the rich silver mining camp of Tombstone. Fort Huachuca is the only one of more than 70 military posts established in the late 19th century in southern Arizona that is still active today. No tourist could go wrong by visiting its wonderful museum. To the north of the fort are the Mustang and Whetstone Mountains, to the south are the Sierra Azules and the Sierra Madres of Mexico, and off to the west Mount Wrightston rises high in the Santa Rita Mountains. The fort, nestled in Huachuca Canyon, protected the early immigrants from Apache attacks.

From their hideouts in the silent mountain passes, the vigilant Apaches watched their lands disappear to immigrant invaders. They fought when their lifestyle was in jeopardy and carried on a sustained battle against those who violated their territory. The solitary prospector, searching for riches in gold and silver, could well expect a swift silent arrow instead. It would be a long time, if ever, before his bleached bones were discovered. Ultimately the Native American was conquered by a technologically advanced civilization. Today Fort Huachuca sends motor convoys onto the highways with soldiers destined for distant lands. Still, in the twilight and early dawn, one can almost hear the plaintive notes of tattoo and taps from a time long past.

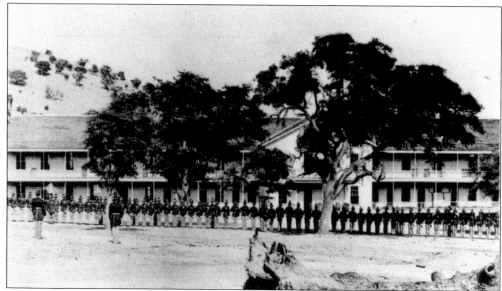

Soldiers participate in a Sunday parade at Fort Huachuca, c. 1880. Historians and ethnologists disagree over the meaning of the word "Huachuca" but all agree that it is an Indian word. Some believe that it is an Apache word meaning thunder while others say it is a Pima word meaning "it rains here." Still a third interpretation says that the word is of Athapascan origin meaning "where the bee spreads out." Nearby Huachuca Peak is also called Thunder Mountain. (Courtesy Fort Huachuca.)

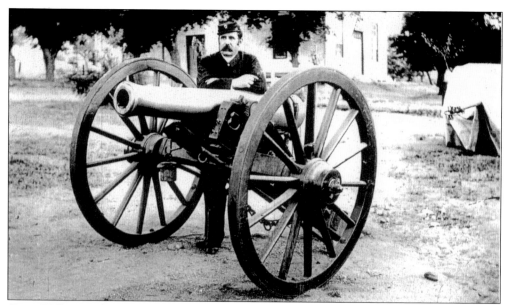

Capt. William Deleney fires the evening gun at Fort Huachuca, c. 1888. The soldiers of Fort Huachuca fell out in the morning and went to bed at night to the reveille, taps, and the earsplitting thunderclap of a 12-pound Napoleon gun. At the second call, the details marched to the parade ground and were inspected by the post adjutant as the band played music such as the "Secession Polka." The new guard mounted their prancing steeds and set off to relieve the old guard, providing a stirring spectacle. (Courtesy Fort Huachuca.)

Like soldiers everywhere the men at Fort Huachuca cursed wake-up call. These frontier soldiers were blasted out of bed to the sound of a 12-pound cannon! Pity the poor soldier with a hangover from a payday spree. A breakfast of mush or pork was served around 5:30 a.m., but on Sundays soldiers were served bacon, eggs, pancakes, and strong coffee. Drill, inspection, and the workaday routine, which included scouting, escorting pay wagons, stringing telegraph wires, and keeping peace at saloons and whorehouses, followed afterwards. (Courtesy Fort Huachuca.)

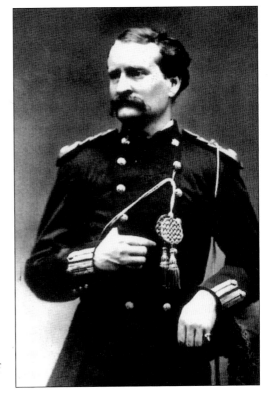

Capt. Samuel Marmaduke Whitside, born January 9, 1839, in Toronto, Ontario, was described as 5 feet, 7.5 inches tall with blue eyes and light hair. He founded Fort Huachuca on March 3, 1877, and served as commander of the post until 1881, except for a brief period in 1879 when he was removed to Fort Thomas with a broken leg. He returned in March but became ill and was sent to Los Angeles for recuperation. Upon his arrival, Whitside wrote in his log book, "Camp Huachuca, Huachuca Mountains, Arizona Territory, Capt. S.M. Whitside, Commanding Officer." Whitside founded Fort Huachuca. He later fought in Cuba and visited Panama with a Congressional delegation. Dallas Whitside, the infant son of the captain and his wife Carrie, was the second person to be buried at the post cemetery on December 28, 1880. Whitside died on December 15, 1904, from an attack of acute indigestion. (Courtesy Fort Huachuca.)

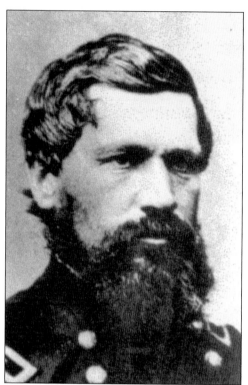

Maj. Gen. Oliver Otis Howard served as commanding general of the Division of the Pacific from 1886 to 1888. In 1872 he had been President Ulysses S. Grant's personal representative to the Apaches in New Mexico and Arizona. From Fort Huachuca, Howard made pacification attempts with the Apaches for which he was criticized. He did stop the Chiricahua Apaches from marauding in Arizona. Howard's son Guy also served at Fort Huachuca and commanded an Indian Scout Company in 1879. (Courtesy National Archive, Washington D.C.)

Gen. George Crook and his military personnel camped near Fort Huachuca. Crook, born at Dayton, Ohio, on September 6, 1828, is seated in the center and wearing a white hat. Crook was promoted from major to brigadier general over more than 46 colonels and lieutenant colonels. Although considered by many to be the finest of the Indian fighters, Crook failed to capture the wily Geronimo and this situation ultimately forced his resignation. (Courtesy Fort Huachuca.)

Gen. George Crook poses with his Apache scouts. Crook had a high regard for the Apache scouts, who enlisted for periods of 3, 6, or 12 months and often reenlisted several times. Unfortunately an army circular of 1887 denied the inclusion of Indian scouts on a list for meritorious achievements at any military post but allowed them to earn marksmen's certificates and insignia. An Army circular in 1890 specified in detail the basic items of scout dress but most wore whatever they wanted. (Courtesy Fort Huachuca.)

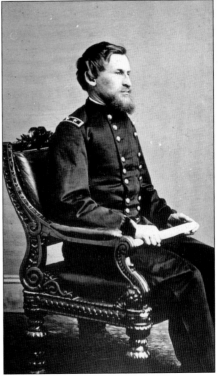

Brig. Gen. George Crook is seen here in a comparatively rare photograph as a young officer. He commanded a cavalry division in the Army of the Cumberland during the Civil War and succeeded Maj. Gen. David Hunter as commander of West Virginia in 1864. Crook was active in the Shenandoah Campaign under Sheridan and present at Appomattox. He was also present at Rosebud on June 18, 1876, in the fight against the Sioux. Crook commanded the Department of Arizona from 1870 to 1875 and again from 1882 to 1886 during which he participated in the Apache Campaign. (Courtesy Matthew Brady Collection, National Archives.)

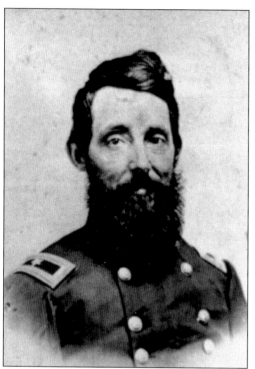

Gen. Benjamin Henry Grierson was a seasoned Civil War veteran when he arrived in Arizona to take part in the 1880 10th Cavalry campaign against Victorio. Grierson became the first commander of the all-black regiment known as the Buffalo Soldiers. The Buffalo Soldiers were frequent victims of prejudice and Grierson objected to the use of the word "colored," saying that "These men are soldiers of the 10th United States Cavalry, nothing more, nothing less." Grierson wrote, "Fort Huachuca is in good repair and on account of its proximity to the Mexican line and the railroad leading into Mexico should be retained and fully garrisoned for some years to come." Grierson ended his Army career as commander of the Department of Arizona from 1889 to 1890. (Courtesy Fort Huachuca.)

Troop I, 4th Cavalry poses for a picture in Bisbee Canyon in 1884. At the far lower right is the Apache Kid who spoke fluent English and served as a trusted scout until he became the focus of national attention as an outlaw. The only other identified soldier is Emil Pally who appears in the center of the photo with stripes on his arms and holding a Winchester Hotchkiss repeating rifle. (Courtesy Fort Huachuca.)

Lt. Charles Bare Gatewood, an 1877 graduate of West Point posted to the Cavalry in the West, served under Gen. Nelson Appleton Miles in Arizona and New Mexico. Gatewood, who had studied the Apache ways and language, was given the task of convincing Geronimo to surrender to Miles. Miles became jealous when Gatewood got too much credit for Geronimo's capture and had him transferred to the Dakotas. While serving at Fort McKinley, Wyoming, Gatewood was seriously injured by a premature explosion when he tried to blow up a burning building to save other buildings. Gatewood was sent to Fort Monroe, Virginia, for treatment but died on May 20, 1896, of stomach cancer. His body was transported by steamer to Washington D.C., where it traveled by caisson to Arlington National Cemetery for interment with full military honors. He is buried in Section One of Arlington National Cemetery alongside his beloved wife who had traveled the West with him. (Courtesy National Archives, Washington D.C.)

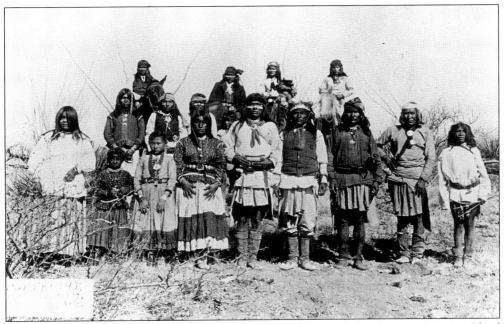

A group of Apaches surrenders to General Miles. This photo includes the scout Martine (third from left, middle row), who traveled with Lieutenant Gatewood. (Courtesy Signal Corps Photo, National Archives.)

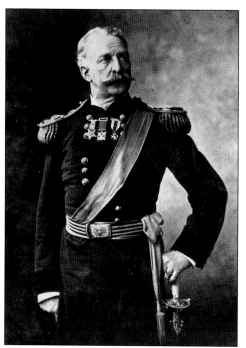

Gen. Nelson A. Miles is pictured here with the Tiffany sword presented to him by the citizens of Tucson for his part in the capture of Geronimo. Miles was commissioned as captain of the 22nd Massachusetts Volunteer Infantry at the outbreak of the Civil War. He was promoted to colonel after assuming command of his regiment during the battle of Antietam on September 17, 1862. After the war, he became the custodian of Jefferson Davis and received public criticism for keeping him shackled in his cell. He captured Chief Joseph in 1877 after the Nez Perce's incredible march toward sanctuary in Canada. In April 1886 Miles succeeded Crook as the commander of the Department of Arizona. His reputation was permanently tarnished by the massacre of some 200 Sioux, including women and children, by troops under the command of Col. James W. Forsyth at Wounded Knee. (Courtesy Fort Huachuca.)

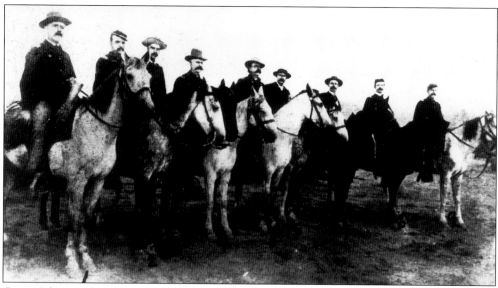

Gen. Nelson Miles assembles his prestigious staff at Fort Bowie as they plan the capture of Geronimo. Pictured, from left to right, are Dr. Leonard Wood, Medical Corps; Lt. Robert Fisher Ames, 8th Infantry, who was found guilty of conduct unbecoming an officer and a gentleman when Lt. C.J. Janney committed suicide after he accused Ames of improper relations with his wife; Lt. Wilber Elliott Wilder, 4th Infantry, who received a Medal of Honor for helping a wounded soldier under heavy fire; Capt. Henry Ware Lawton, 4th Cavalry, who escorted Geronimo to his meeting with Miles; Gen. Nelson Miles, department commander; Capt. William Alexis Thompson, 4th Cavalry, who in 1903 taught military science at St. John College at Annapolis; Maj. A.S. Kimball, quartermaster; Lt. J.A. DePrey; and Lt. Thomas J. Clay, 10th Infantry. (Courtesy Fort Huachuca.)

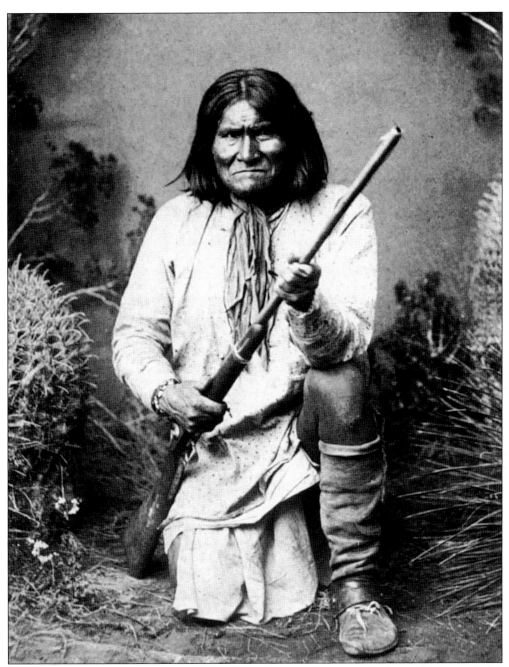

Geronimo poses for his most famous portrait taken by Ben Wittich at the San Carlos Reservation in 1884. On September 4, 1886, Geronimo, the leader of a band of Chiricahua Apaches, surrendered to Gen. Nelson Miles at Skeleton Canyon on the Mexico border. While the settlers would now find southern Arizona safe, Geronimo grieved at the degradation of his people now confined to reservations and the hopelessness of the situation. His followers imbued him with supernatural powers including the ability to stop a sunrise so that they could cross open ground in the darkness of the night. One man said, "So he sang and the night remained for two or three hours longer. I saw this myself."

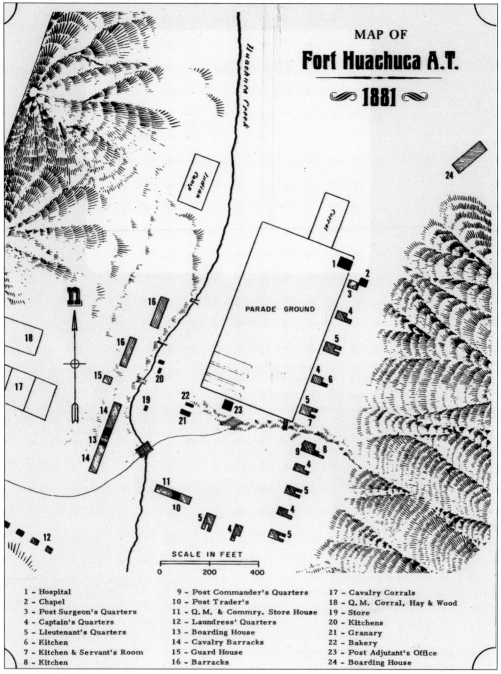

MAP OF
Fort Huachuca A.T.
⟨⟩ 1881 ⟨⟩

PARADE GROUND

SCALE IN FEET

0 200 400

1 – Hospital	9 – Post Commander's Quarters	17 – Cavalry Corrals
2 – Chapel	10 – Post Trader's	18 – Q. M. Corral, Hay & Wood
3 – Post Surgeon's Quarters	11 – Q. M. & Commry. Store House	19 – Store
4 – Captain's Quarters	12 – Laundress' Quarters	20 – Kitchens
5 – Lieutenant's Quarters	13 – Boarding House	21 – Granary
6 – Kitchen	14 – Cavalry Barracks	22 – Bakery
7 – Kitchen & Servant's Room	15 – Guard House	23 – Post Adjutant's Office
8 – Kitchen	16 – Barracks	24 – Boarding House

A map of Fort Huachuca Arizona Territory from 1881 shows the surrounding areas. (Courtesy Don Bufkin.)

18

Two

THE DISCOVERY
OF SILVER

Ed Schieffelin, born in Pennsylvania in October 1847, was one of the few prospectors to discover a rich mother lode. By the time he was 29 years old, he had prospected in Oregon, Idaho, Nevada, Utah, and California, occasionally taking on regular work to feed himself and his burro. In November 1875, when the prodigal son returned to his parents' home in Oregon, he had $2.50 in his pocket. He borrowed $100 from his father and traveled to Arizona. At the Grand Canyon he set out with several Hualapais who were going to southern Arizona to scout against the Apaches. Schiefflin arrived at Fort Huachuca on April 1, 1877. He prospected during the day and returned to the fort at night. The soldiers always asked what he had found. When he replied nothing, they responded that all he would find was his "tombstone." Schieffelin called his first claims the "Tombstone" and the "Graveyard." He then traveled to Mohave County to find his brother Albert, who was working at the McCracken Mine. The Schieffelin brothers met Richard Gird, an experienced engineer, who assayed Schieffelin's fabulously rich ore samples. Within a few months, the area was overrun with prospectors and a tent city grew up in the area known locally as Goose Flats and later as Tombstone.

When Schieffelin discovered another claim, Gird said, "Ed, you lucky cuss, you have done it again." Schieffelin called this claim the "Lucky Cuss," and it produced $1,200 to $1,500 of gold ore and $15,000 of silver ore per ton. The monument on the summit of the Lucky Cuss Hill became the initial point for all Tombstone District Surveys. (Courtesy the Huntington Library.)

After Ed Schieffelin claimed the Lucky Cuss, he told his brother Al and Richard Gird that the next would be a tough nut to crack. He therefore named the new claim Tough Nut. Tough Nut miners received top wages—$4 dollars a day for a 10-hour shift. (Courtesy the Huntington Library.)

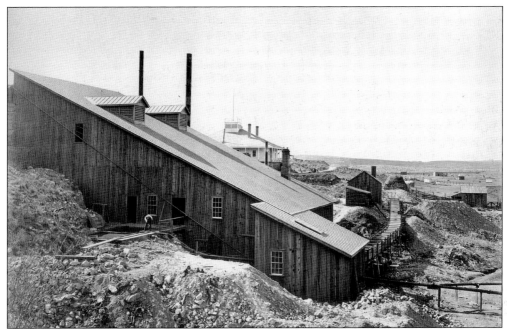

The Tombstone Mine and Milling Company boasted a director's room, a secretary's office, and an assay lab. In the assay room was a large vault with a burglar-proof door where silver bullion was stored until it could be taken to Tucson and deposited in a bank. The company built a small store where food cost the miners $1 a day. (Courtesy the Huntington Library.)

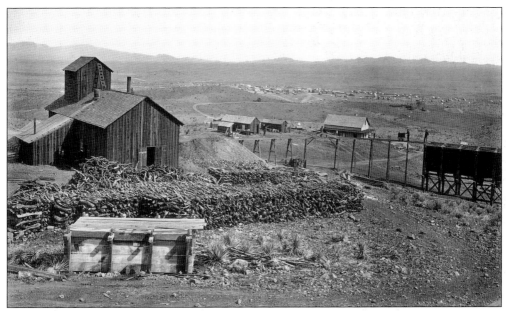

This *c.* 1880 photograph of the hoisting works at Contention shows Tombstone in the background. The Contention mining camp had a reputation for being even rowdier than Tombstone. Just beyond the ore bins is the superintendent's house. In 1882 the Contention Consolidated Company produced 632 bars of silver valued at $1,676,795.95 and employed more than 100 men to work its 20 miles of holdings. (Courtesy the Huntington Library.)

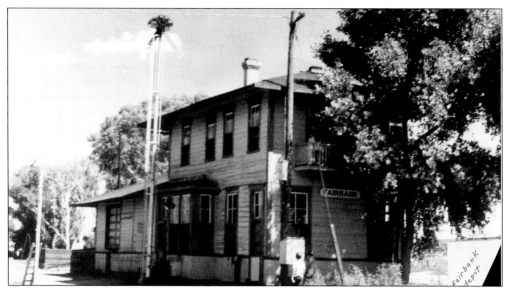

Several towns arose in the shadow of the great silver discovery at Tombstone but most are now only ghosts of their past. N.K. Fairbank organized the Grand Central Mining Company of Tombstone. Fairbank, a Chicago merchant, also held stock in the railroad line from Benson, Arizona, to Mexico, and it was here that a branch line to Tombstone was named after him. (Courtesy Ben Traywick.)

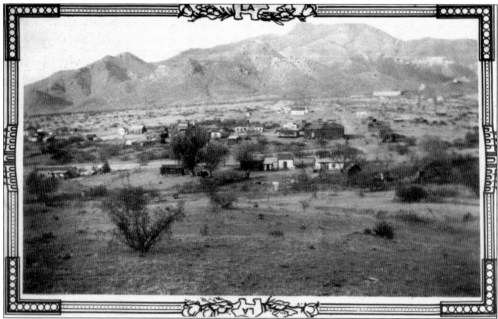

Not far from Tombstone in the shadow of Dos Cabezas (two heads) twin peaks, a town by the name of Dos Cabezas emerged in the 1880s, first as a watering hole for stage lines and later as a mining community. Like most early mining communities it became a hell-raising town and rustlers' rendezvous. However, at one time Dos Cabezas also had homes, a school, hotels, stores, a newspaper, and a respectable number of bars. Today it is not quite a ghost town and boasts a small museum. (Courtesy Glenn Boyer.)

Ed Schieffelin had blue eyes and his long black curly hair hung down to his shoulders. He usually wore a red flannel shirt and tucked his pants into his boots. More often his workaday clothes were patched with deerskin, corduroy, and flannel. His slouch hat was pieced together with rabbit skin. He carried a rifle for protection and to supply himself with meat. (Courtesy Ben Traywick.)

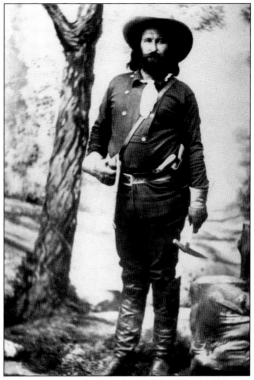

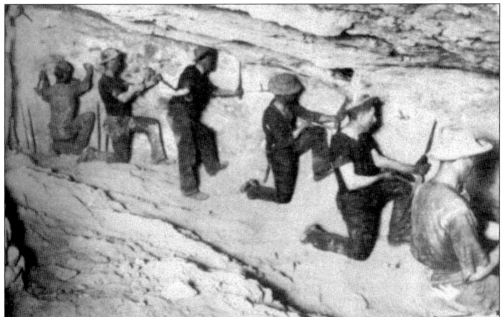

Miners worked by candlelight underground at the Tombstone Consolidated Mine. Clothing included a wide brim hat stiffened with resin, an undershirt, union drawers, woven shirt, baggy trousers, and boots or ankle-high brogans. Many were miners from Cornwall in England, also known as Cousin Jacks, along with Irishmen and refugees from Pennsylvania oil fields. (Author's collection.)

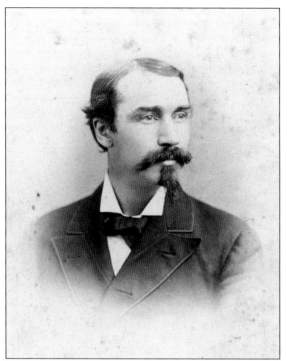

Richard Gird was the first to see the value of Ed Schieffelin's discovery. Gird, born in New York on March 29, 1836, was imbued with his father's philosophy of hard work. At age 16, he traveled to California and learned the assayer's trade. Gird took a job as a civil engineer in Chile and two years later returned to the United States to work in Arizona. In 1864, the First Territorial Legislature of Arizona hired Gird to make a map of Arizona. (Courtesy Arizona Historical Society.)

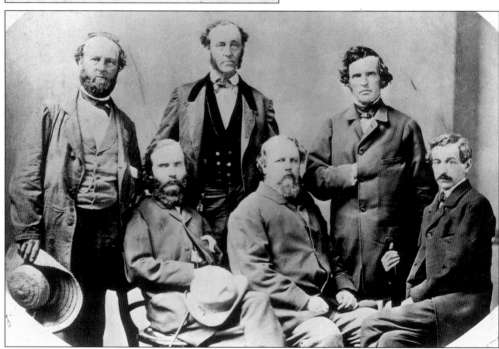

From left to right are, (seated) Associate Justice Joseph T. Allyn; Governor John N. Goodwin; and Arizona Territory Secretary Richard C. McCormick; (standing) Henry W. Fleury, the governor's personal secretary; U.S. Marshal Milton B. Duffield, who was assassinated at the Brunkow mine where Schieffelin and Gird stayed while they were exploring the Tombstone sites; and U.S. District Attorney Almon P. Gage. (Courtesy Arizona Historical Society.)

Al Sieber, chief of scouts for the military, made some claims when the Tombstone strike looked to be very rich. Unfortunately the government needed him at Fort Whipple and he sold out for $2,800. (Author's collection.)

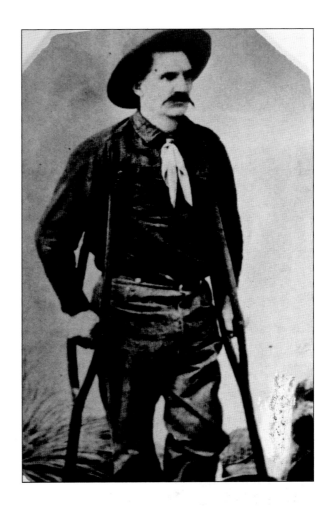

As Tombstone grew wealthier, the town erected permanent buildings as evidenced in this stereopticon view. (Courtesy the Bancroft Library.)

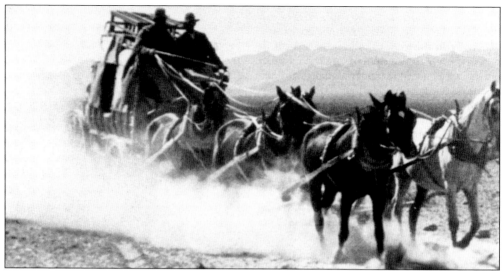

J.D. Kinnear started his Tucson and Tombstone Express with one Modoc stagecoach. He provided once-a-week service; the coach left Tucson on Tuesday and arrived in Tombstone the next day. After a one-night stop it returned to Tucson the following Friday. A passenger could purchase a one-way ticket for $10, and the stage would depart from Rice's Drugstore in Tucson. Within a few weeks, Kinnear was able to purchase a more modern Concord coach. (Courtesy Ben Traywick.)

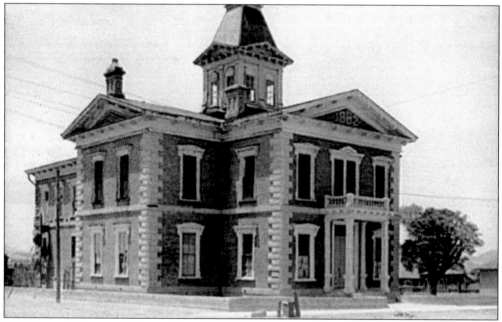

The Eleventh Territorial Assembly carved 4,003,840 acres out of Pima County on February 1, 1881, calling it Cochise County, and Tombstone became its first county seat. In 1931 the county seat moved to Bisbee. The new courthouse was described as a fine two-story structure built on a solid foundation and substantially furnished inside. It also contained the county jails and other county offices with a handsome courtroom on the second floor. Today the Tombstone courthouse is the smallest of the Arizona state parks and functions as a museum that displays historic objects and documents from Tombstone's wild and wealthy past. (Author's collection.)

In 1881 Tombstone built a handsome city hall. This freed Pima County from the expense and the difficulty of preserving the peace. It allowed Tombstone to legally name a town marshal and enact laws. On December 9, 1879, the town was incorporated as the Village of Tombstone. Some wanted the name changed but by that time Tombstone was too well known. (Author's collection.)

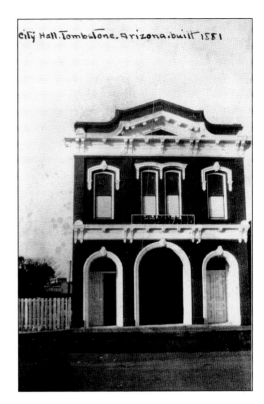

City Hall. Tombstone. Arizona. built 1881

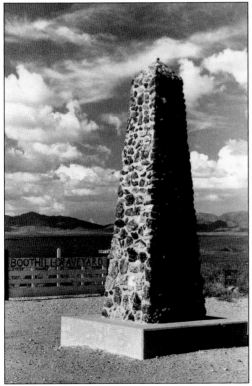

Ed Schieffelin died on May 14, 1896, in his cabin in Oregon. He had written, "I am getting restless here in Oregon. . . . I like the excitement of being right up against the earth, trying to coax her gold away and scatter it." He left his property to his wife and $15,000 in University of Arizona bonds to his brother Charles. His will reflected his love of Tombstone.

> It is my wish, if convenient, to be buried in the dress of a prospector, my old pick and canteen with me, on top of the granite hills about three miles westerly from the City of Tombstone, Arizona, and that a monument such as prospectors build when locating a mining claim be built over my grave, and no other slab or monument be erected. And I request that none of my friends wear crape [sic]. Under no circumstances do I want to be buried in a graveyard or cemetery.

27

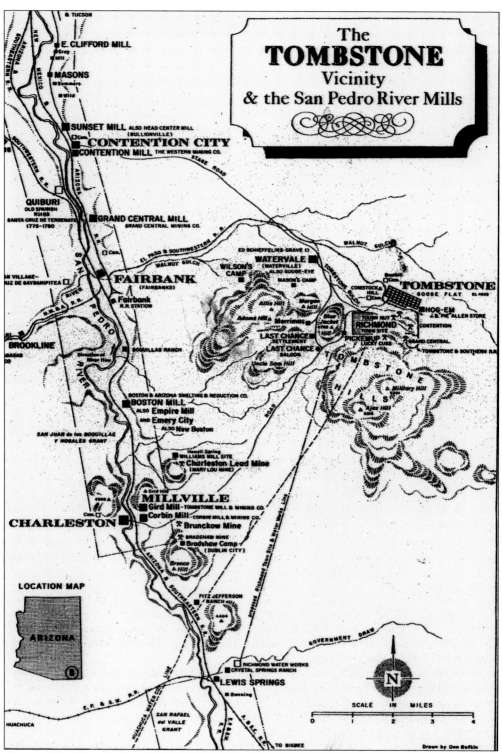

This is a map of the Tombstone Arizona Vicinity and the San Pedro River Mills. (Courtesy Don Bufkin.)

Three

THE GROWTH OF TOMBSTONE

Tombstone, best remembered for the notorious fight at the O.K. Corral, had a population of 10,000 around 1880. Although the mining camp acquired a reputation as a wild and raucous town, it also had four churches, a school, two banks, several newspapers including the *Epitaph*, the *Nugget*, and the *Prospector*, an opera house, the Bird Cage Theatre, Schiefflin Hall, and a meeting hall for the Masonic Lodge.

The news of the great strike brought a surge of restless prospectors and miners, merchants who were happy to sell supplies at grossly inflated prices, gamblers quick to part miners with their money, and Ladies of the Night ready to trade pleasure for money. At first the site was known as Gird Camp, then Watervale or Waterville. On May 9, 1880, the Tombstone Townsite Company was registered with the territorial land office. The deed for this company was registered in the name of the mayor, Alder Randall. However, people soon discovered that their deeds were faulty and this brought on fights. Still, buildings went up as fast as lumber could be brought in the place now known as Tombstone.

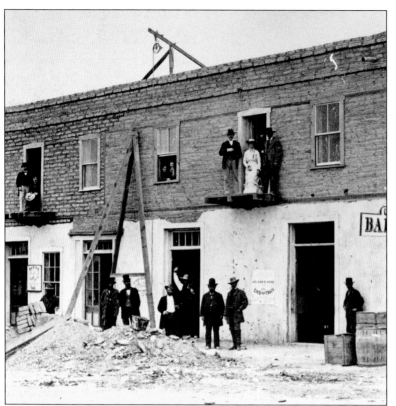

Carl Gustave Frederick Billicke built Tombstone's first two-story hotel, the Cosmopolitan, in 1880. A year earlier, his first hotel, a tent, offered guests fresh milk from his own cow. This German immigrant furnished his hotel with 50 beds, a restaurant, a Steinway piano, and a "decent" saloon. The second story was furnished with 25 beds and a lady's parlor. (Courtesy Arizona Historical Society.)

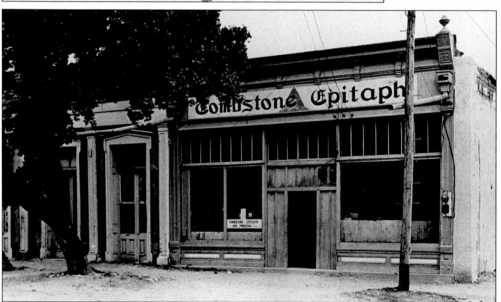

The Tombstone *Epitaph* was founded May 1, 1880, by John Philip Clum who followed the silver trail to Tombstone. He claimed to have coined the name as appropriate to a paper that chronicled the events of a town named Tombstone. By the following January, Clum had become embroiled in the political and social quarrels of the town. Today the Tombstone *Epitaph* is still published. (Author's collection.)

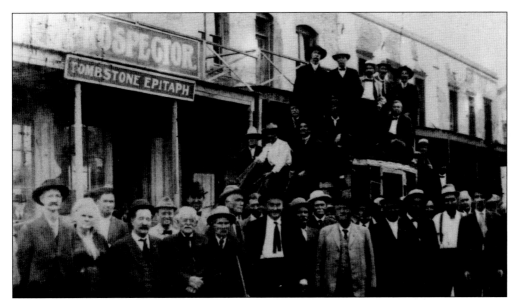

On August 23, 1915, the Tombstone *Prospector* and the Tombstone *Epitaph* merged in a special ceremony. When Judge William H. Barnes rendered a verdict against the *Prospector*'s editor Stanley C. Bagg, Bagg responded, "We take our medicine with good grace and we hope the Honorable judge and the Honorable Board of Supervisors will not make any grimaces in taking the pills which have been prescribed for them by our editorial surgeon." The comment so enraged the judge that he sentenced Bagg for contempt. The editor, who was to be jailed until his fine of $300 was paid, expected to sleep comfortably in the sheriff's office, but instead had to sleep on the floor of his jail cell. (Courtesy Ben Traywick.)

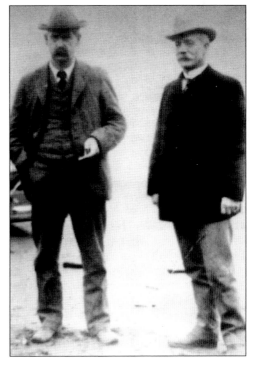

Wyatt Earp (left) and John Clum (right) pose for a photo in Alaska years after the O.K. Corral fight. John Clum, born in New York on September 1, 1851, served as an Apache agent, editor, and Tombstone mayor and is best remembered as a staunch defender of the Earps after the famous street fight. In the spring of 1882 Clum sold his newspaper to a group of prominent, wealthy Democrats. (Author's collection.)

When Mary Clum died on December 19, 1880, the Tombstone *Epitaph* reported, "Another heart is stifled in eternal silence, another headstone made desolate." Mary D. Ware, born in Cincinnati on January 18, 1853, married John Clum in Delaware in November 1876. (Courtesy Ben Traywick.)

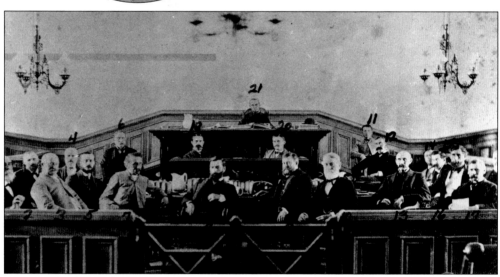

By 1883 Tombstone had a large number of attorneys. They are as follows: 1. Charles Clark; 2. George Williams; 3. Col. William Herring; 4. James Reilly; 5. Thomas Mitchell; 6. Judge Peel, whose son was killed in Charleston, Arizona, by Zwing Hunt and Billy Grounds; 7. unidentified; 8. John F. Lewis; 9. Henry F. Dibble; 10. unidentified; 11. unidentified; 12. Marcus A. Smith, who later became a territorial representative to Washington D.C.; 13. John Haynes; 14. unidentified; 15. Webster Street; 16. unidentified; 17. Ben Goodrich; 18. George Berry; 19. William J. Seamans; 20. Casey Clum, who was either a brother or a nephew of John Clum; and 21. Daniel Pinney, who served as judge during the Bisbee Massacre. (Courtesy Arizona Historical Society.)

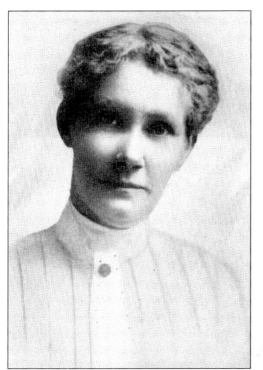

Sarah Herring grew up in Tombstone and worked for her father's law firm. On November 24, 1892, she passed a rigid law examination with distinguished honors. A month and a half later Sarah was admitted to practice before the Supreme Court of Arizona. Sarah made her first appearance before the Arizona Territorial Supreme Court in 1896. An injured miner, Michael Welch, had obtained a $5,000 judgment in a lower court against his employers, who hired Sarah to appeal the decision. In her closing statement she showed that Welch had brought on the accident himself. The Supreme Court reversed the lower court ruling and ordered a new trial. (Author's collection.)

Judge James S. Robinson, born in Culpepper County, Virginia, partnered in a legal practice with Marcus Smith in Tombstone. He represented Ike Clanton in the Earp hearing after the gunfight with the Earps and Holliday. He also urged the Tombstone populace to rid itself of the "Chinese evil." Robinson died in Tombstone on May 20, 1903. (Author's collection.)

Lee Woolery passed the Indiana bar examination in 1903, the same year he moved to Arizona. He and his brother bought a ranch along the San Pedro River; however, before long he had a legal practice, with most his cases involving mining litigation. He held offices such as deputy county recorder, city clerk, city attorney, and county attorney. (Author's collection.)

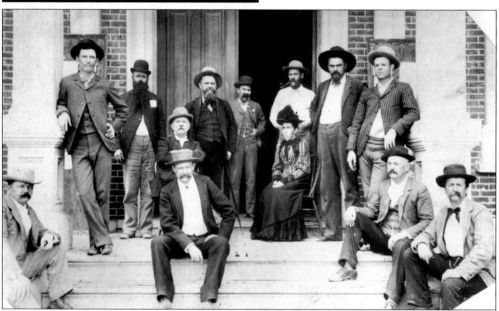

Early Tombstone officials pose for a photograph. From left to right are (standing) Deputy Sheriff Billy Bradley, County Attorney George Washington Swain, an unidentified clerk, Clerk of the Court A.H. Emanuel, unidentified, Jailor William Ritchie, and Nat Hawke; (seated) D.H. Wardwell, unidentified, attorney W.C. Steahle, County Treasurer M.D. Scribner, A.W. Wentworth, and W.D. Monmonier. (Courtesy Arizona Historical Society.)

Dr. George E. Goodfellow spent his youth in the California gold fields. As a surgeon he figured prominently in patching up Tombstone's citizenry involved in mining disasters, fires, street fights, bar brawls, and duels. When an earthquake devastated Bavispe, Mexico, in 1887, Goodfellow led a mercy expedition for which he was honored by the president of Mexico. He served as head surgeon for the Southern Pacific Railroad and became the Arizona Territory's health officer. (Courtesy Arizona Historical Society.)

Dr. Harry Houston Hughart, M.D., born in Virginia on September 11, 1876, was for many years the only physician in Tombstone. He was described as "giving allegiance to the democratic party and his religious doctrines were in accord with the doctrines of the Presbyterian church." He came to Tombstone in 1903 and served as superintendent of the Cochise County Hospital for five years. (Author's collection.)

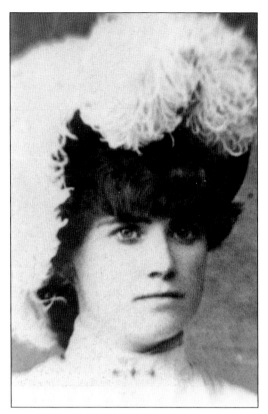

Nellie Cashman, born in County Cork, Ireland, in 1845, was known as the "Angel of Tombstone." She never turned away anyone who was hungry for lack of money, and it was said that anyone criticizing the cooking in her restaurant would find himself looking down the barrel of a gun until he apologized. From 1904 to 1925 Nellie prospected in the Yukon. In 1994 a 29¢ stamp was made in her honor as part of the Legends of the West series. (Courtesy Ben Traywick.)

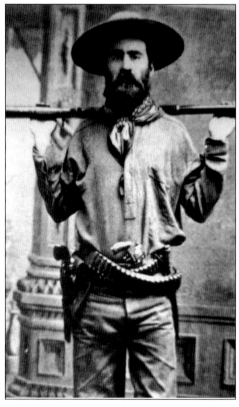

George Whitwell Parsons was an Eastern tenderfoot banker who soon became an experienced prospector. He was also an amateur actor and a wrestler, but Parsons is best remembered as a journalist who kept a detailed diary of Tombstone during its boom times. He frequently lamented the lack of eligible women. He began his journal in 1879 and wrote his last entry on December 31, 1929. When Tombstone fell on bad times, Parsons moved to California. (Author's collection.)

Abraham Hyman Emanuel was born about 1838 in Philadelphia. At age 12, he and Cornelius Vanderbilt, grandson of Como. Cornelius Vanderbilt, ran away from preparatory school and got as far as Panama when they ran into the old commodore himself. Emanuel ran away again and reached California where he was given a job as clerk by Judge McAlister. When Emanuel heard about the big silver strikes, he traveled to Tombstone where he worked as a superintendent of the Tombstone Water, Mill and Lumber Company. Emanuel speculated in stocks and in 1880 he sold his claims of the Vizina Mine to Wyatt and Virgil Earp. In 1889, Judge Richard E. Sloan appointed Emanuel, a staunch Republican, as clerk of the Cochise County Court. Seven years later he was elected mayor of Tombstone and was reelected for two additional terms. In 1902, Mayor Emanuel got Ordinance 69 passed, which granted Charles Gage the right to develop the Tombstone Light and Gas Works. However, that year Emanuel was defeated by Arioch Wentworth. In his departing speech Emanuel graciously welcomed the new mayor. (Courtesy Abe Chanin.)

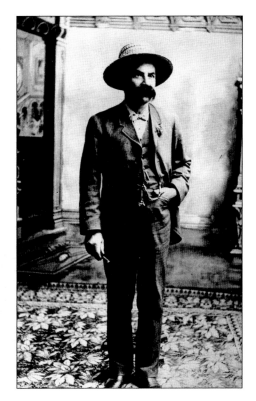

Arioch Wentworth, born on October 2, 1859, in Corlina, Maine, practiced the tanning trade before coming to Fairbank, Arizona, in 1885 with the New Mexico & Arizona Railroad. He then became an agent of Wells Fargo & Company and he established the Tombstone Billiard Parlor. In 1902 he defeated Abraham Emanuel for the mayoral office. He also acted as the secretary of the Rescue Hose Company. Wentworth died on March 2, 1921, in Tombstone. (Author's collection.)

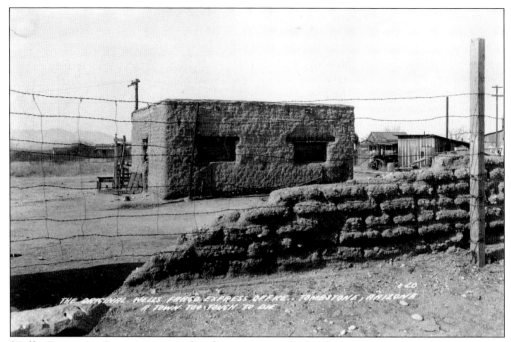

Wells Fargo & Company was the first to provide banking services in Tombstone. A holdup of its stage also gave impetus to the ill feeling that led to the famous gunfight. (Courtesy Ben Traywick.)

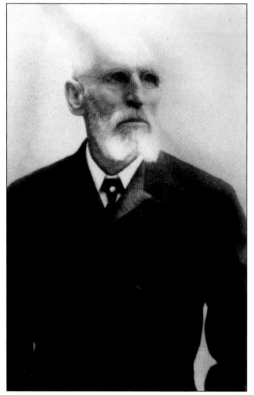

Artemas Louden Grow, a Union veteran of the Civil War, spent 44 years in the Tombstone area. He came to Tombstone in 1879 as a customs collector when the town served as a port of entry between Mexico and the United States. As superintendent of the Tranquility Mine, he worked to repay all the company's debts and put it on a paying basis. In 1903 he served as a delegate from Tombstone to the Republican Convention. (Author's collection.)

James Franklin Duncan, born in Philadelphia on June 15, 1839, came to Tombstone in 1879. In November he was elected to the Twelfth Territorial Legislature from Cochise County. In 1892 he became a justice of the peace in Tombstone and served three terms as Tombstone alderman. He wrote a series of reminiscences of Bisbee titled *Bisbee with a Big B*. (Author's collection.)

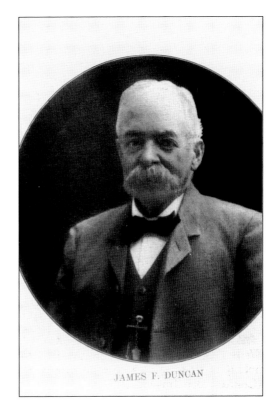

JAMES F. DUNCAN

Tombstone's first school opened in February 1880 with nine students in a small room with a dirt floor. By the end of the term more than 40 students were in attendance. The desks consisted of boards spread across packing boxes. The seats were made by placing planks on nail kegs and the teacher's desk was a flour barrel turned upside down. Textbooks were any books that could be found. (Courtesy Arizona Historical Society.)

An early boy scout troop gathers in Tombstone. (Courtesy Sharlot Hall Historical Society.)

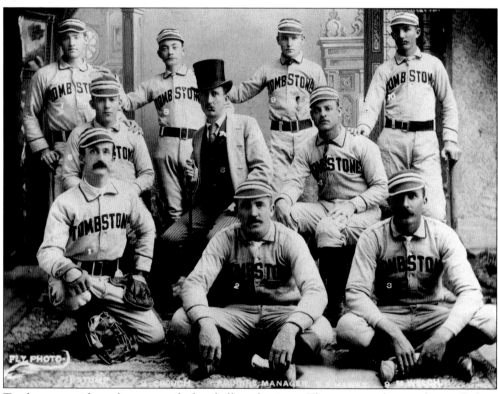

Tombstone residents became early baseball enthusiasts. The man in the top hat is Robert "Sandy Bob" Crouch, a native of Ohio, who started a Tombstone stage business in 1880 and ran stagecoaches to Bisbee and Fairbank. In 1883 he bought the Gordon Ranch and put his son in charge until Apache raids forced the sale of this property. Sandy Bob also supplied wood to the Copper Queen Company in Bisbee. In 1895, Crouch moved to Mexico City and died at Guadalajara on September 10, 1908. (Courtesy Arizona Historical Society.)

China Mary is believed to be Mary Sing Choy, born in China. She ruled Tombstone's 400 Asian population while wearing opulent brocades and expensive jewelry, and her word was undisputed law in Tombstone's Chinatown. She acquired enough money to buy several pieces of property between 1895 and 1896, and if you wanted a cook, clothes washed, or housecleaning, you dealt with China Mary. She also handled the distribution of opium to the red light district and peddled Chinese prostitutes. Her store carried Chinese delicacies and she operated gambling tables in the back rooms. She was the wife of Ah Lum, and died in Tombstone on December 16, 1900, at 67. (Courtesy Ben Traywick.)

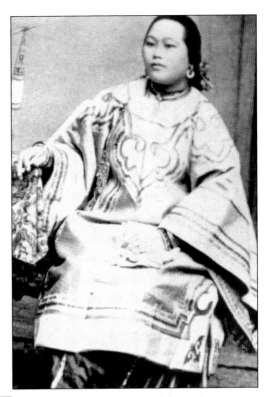

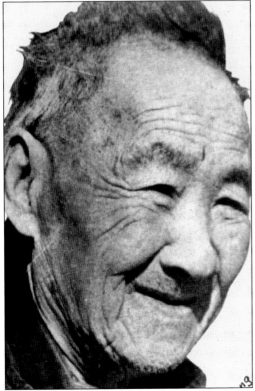

When the hearse arrived at Boothill in January 1938, a crowd had already gathered to bid farewell to the last member of Tombstone's Chinese community, Quong Kee. Quong's pallbearers included Dave O'Neal from the State Tax Commission; John Gleeson, founder of the town of Gleeson; J.W. Smith; G.J. McCabe; and George Berger. Two attending Chinese men, Gee Hing and Yee Wee, claimed to be Quong Kee's cousins. Quong made his reputation on his restaurants—the Black Diamond in Pearce; the Grecian in Charleston, near Tombstone; and the famous Can-Can in Tombstone. During his last years Quong and his little dog subsisted on county alms and friends' charity. (Courtesy Ben Traywick.)

Reverend Endicott and Francis Peabody are pictured here on their honeymoon June 1885. Peabody arrived in Tombstone on January 29, 1882. The Tombstone *Epitaph* reported on February 13, 1882, "We've got a parson who doesn't flirt with the girls, doesn't drink behind the door and when it comes to baseball, he's a daisy." Peabody, vice president of the Tombstone Baseball Association, organized the town's baseball team. He served as the official umpire at all baseball games and when asked to umpire a Sunday game he agreed on the condition that the players first attend services. (Courtesy Groton School.)

Reverend Peabody attended local horse races and often put on boxing gloves. A disastrous fire on May 25 devastated Tombstone, and Peabody helped move the cartridges and powder that might have exploded. The fire broke all the windows in the courtroom and necessitated finding a place to meet for Sunday services. Peabody worked hard fund-raising for the construction of a new church. The first services were conducted in the new St. Paul's Church on June 18. After his Tombstone ministry, with support from wealthy Bostonians, he organized and was appointed headmaster of the church-affiliated preparatory Groton School at Groton, Massachusetts. He held this position until his retirement in 1940. He visited Tombstone on February 16, 1941, on the 59th anniversary of his ministry. St. Paul's, the oldest Protestant church in Arizona, still stands. Reverend Peabody died in 1944 at 87. (Courtesy Groton School.)

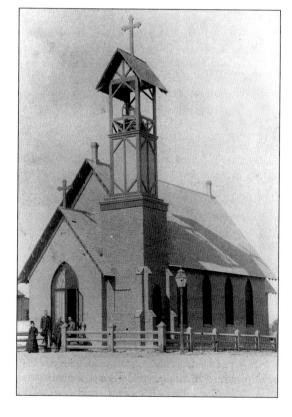

The First Congregational Church and part of the parsonage are pictured here. Episcopalians, Presbyterians, Congregationalists, and Catholics all established early churches wherever they could in Tombstone. It would not be long before substantial buildings replaced tents. All were welcome at services be they upstanding citizen or of ill-repute and easy virtue. (Author's collection.)

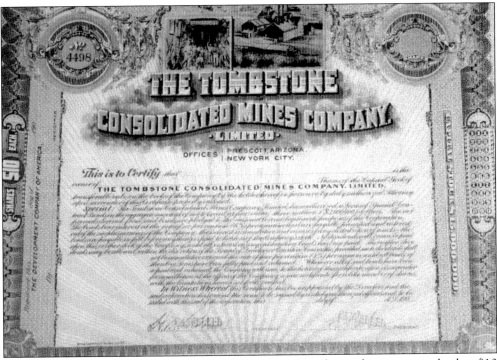

The Tombstone Consolidated Mines Company Limited stock certificates were valued at $10 silver. These beautiful old certificates were printed on elaborate backgrounds with pictures of the mine operation. The mine's 1902 prospectus claimed that it had consolidated and secured title to more than 70 major silver mines in Tombstone. Eventually underground water drove the company out of business. (Author's collection.)

The Contention Consolidated acquired the richest mine in the district for a mere $10,000. The company failed, not for lack of rich ore, but because the underground water could not be pumped out fast enough. (Author's collection.)

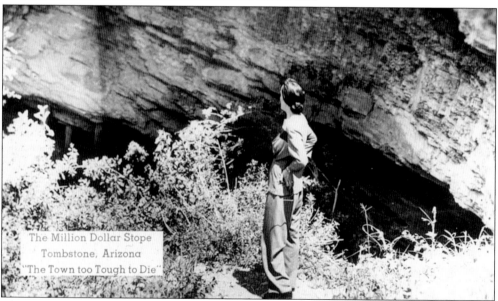

The Million Dollar Stope
Tombstone, Arizona
"The Town too Tough to Die"

This postcard shows the million-dollar stope on Tough Nut Street in Tombstone where the silver came out of the ground. (Author's collection.)

Four

GUNFIGHT AT THE
O.K. CORRAL

Tombstone, best remembered for the notorious fight at the O.K. Corral, had a population of 10,000 in 1881. In fact, the gunfight did not even take place in the O.K. Corral but outside of it. It was Hollywood that declared the fight to be in the corral. The Earp and Clanton feud culminated in the famous battle on October 26, 1881, when Ike Clanton and the McLaury brothers, Billy and Tom, shot it out with Wyatt, Morgan, and Virgil Earp, and Doc Holliday. Virgil had received word that the cowboys were armed and gathering at the O.K. Corral. Doc Holliday met the Earps on their way to the O.K. Corral and insisted on joining them. Just who shot first is a matter of great historical debate. What is known is that, in a hail of bullets from the Earps and the cowboys, Doc shot Billy in the chest and cut Tom McLaury down. When Ike Clanton ran, Holliday fired two shots, missing him narrowly. A bullet from Frank McLaury cut into Doc's pistol holster and burned a painful crease across his hip. Doc's return shot smashed into McLaury's brain. Less than 30 seconds after the opening shot, three men lay dead and three were wounded. Doc had shot each of the dead cowboys at least once. Virgil Earp had been shot in the leg and Morgan through both shoulders. Only Wyatt Earp survived the fight unwounded.

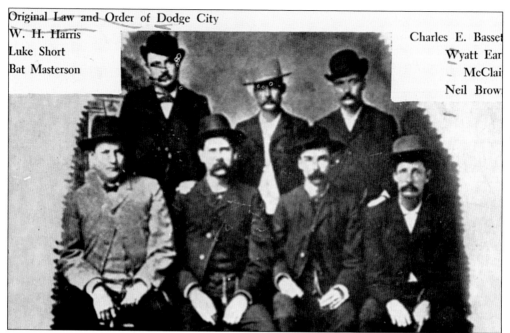

Pictured is an assembly of the most famous frontier lawmen at Dodge City. From left to right are (standing) W.H. Harris, Luke Short, and Bat Masterson; (seated) Charles Bassett, Wyatt Earp, W.F. McLain, and Neil Brown. (Author's collection.)

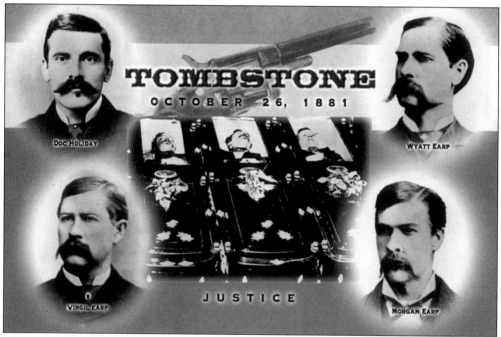

The principles in Tombstone justice on October 26, 1881, were John Henry "Doc" Holliday, Wyatt Earp, Virgil Earp, and Morgan Earp. In the coffins are Tom McLaury, Frank McLaury, and Billy Clanton. A banner draped over their caskets proclaimed "Murdered in the Streets of Tombstone."(Author's collection.)

Wyatt Stapp Berry Earp was born in Monmouth, Illinois, on March 19, 1848. In 1864 the family moved to California but five years later Wyatt traveled to Lamar, Missouri, where he ran unsuccessfully for town marshal. Shortly after marriage, his wife died and Wyatt drifted to Kansas where he worked a while as buffalo hunter. He then served as a policeman in Wichita before moving on to Dodge City. While serving as a deacon in the Union Church of Dodge City Wyatt supplemented his income as a gambler. It was here that he met men such as Pat Masterson and Luke Short, the mean proprietor of the Long Branch Saloon. (Courtesy Ben Traywick.)

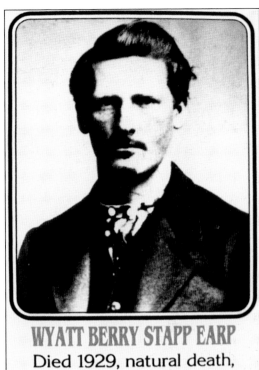

WYATT BERRY STAPP EARP
Died 1929, natural death, Los Angeles, California.

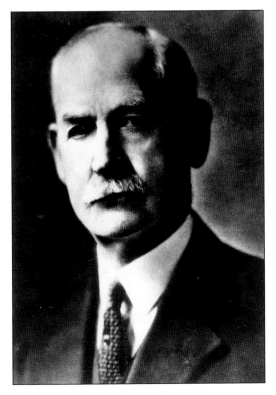

In 1879 the Earp brothers, along with Wyatt's new wife, Mattie Blaylock, made their trek west. Wyatt received a Pima County deputy sheriff commission from Sheriff Charles Shibell. Then, in an abrupt turn of allegiance, Shibell dismissed Wyatt and appointed Johnnie Behan as deputy sheriff, which started a hatred between the two men. It did not help matters when Josephine Sarah Marcus switched her affections from Behan to Wyatt. Behan went on to become the first sheriff of Cochise County. After losing his deputy's commission, Wyatt rode shotgun for Wells Fargo & Company guarding strongboxes. (Author's collection.)

47

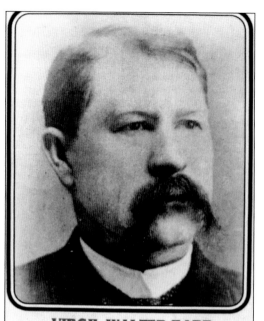

VIRGIL WALTER EARP
Died 1905, pneumonia,
Goldfield, Nevada.

Virgil Earp drove a stagecoach, worked on a ranch, and served as a peace officer after the Civil War during which he had been a Union soldier. He and his wife, Allie, settled in Prescott, Arizona, in 1876. Virgil became a United States deputy marshal on November 27, 1879. He ran for Tombstone city marshal in 1881 but was defeated by Ben Sippy. Virgil was wounded in the gunfight at the O.K. Corral. Two weeks after the gunfight Virgil was ambushed and received a crippling wound from which he never fully recovered. (Courtesy Glen Boyer.)

Morgan Seth Earp was born on April 24, 1851, in Marion County, Iowa. Morgan, the third Earp brother to participate in the famous gunfight, recovered from his wound, but was assassinated in Campbell & Hatch's Saloon in Tombstone on March 18, 1882. A second bullet evidently intended for Wyatt, who was watching his brother shoot pool, went wide of the mark. Morgan was shot through the spine from a window on the back door of the saloon. A coroner's jury decided that the murderers had been Frank Stillwell, Pete Spence, Indian Charlie, and John Doe. Until he could be transported to California, Morgan was laid out at the Cosmopolitan Hotel in a blue suit belonging to Doc Holliday. An armed guard of 15 men accompanied the body to Contention and from there Wyatt and Warren Earp, Doc Holliday, Sherman McMasters, and Turkey Creek Jack Johnson traveled with the coffin as far as Tucson, where Wyatt shot Frank Stillwell. (Courtesy Glenn Boyer.)

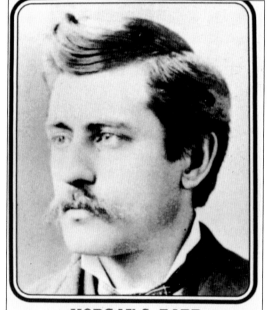

MORGAN S. EARP
Murdered 1882, in
Campbell & Hatch's Saloon

Warren Earp's name is variously listed as Warren Baxter and Baxter Warren. Warren did not participate in the gun battle at the O.K. Corral because he was in Colton, California, working in a grocery story at the time. Upon hearing of the fight, Warren returned to Tombstone to help his brothers. On July 6, 1900, he was assassinated at 1:30 a.m. in Willcox, Arizona, at the Headquarters Saloon. A coroner's jury ruled that Earp was killed by a bullet fired from a gun in the hands of Cochise County rancher John Nathan Boyett. Judge Nichols ruled that there was not enough evidence for an indictment as Boyett acted in self defense. It was generally reported that Warren had challenged Boyett and got what was coming to him. (Courtesy Glen Boyer.)

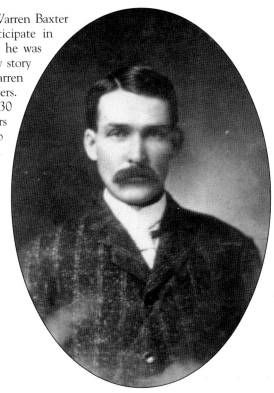

Josephine Sarah Marcus Earp, pictured here wearing a dark suit, and her biographer Viniola Ackermanat pose for a photo at Earp, California, in the 1930s. Josie came from a traditional Jewish family. She got a part with the H.M S. *Pinafore* troupe that performed in Prescott and here she met Johnny Behan. The couple moved to Tombstone where they lived together until Josie took up with Wyatt Earp. (Courtesy of Glenn Boyer.)

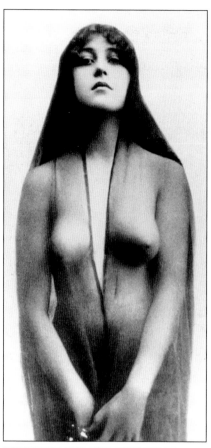

(*above*) Josephine Sarah Marcus Earp is shown here in her later years. A hard life in Arizona and the Yukon took their toll on the once-beautiful actress. Wyatt's liaison with Josie may never have culminated in formal marriage vows but it lasted until his death and she remained ever-protective of his reputation. (Courtesy Glenn Boyer.)

(*left, top*) This is the most controversial photograph purported to be of Josie Earp. It may have surfaced between 1900 and 1914 and is thought to be an old gambler's card. The gauzy dress was drawn over the voluptuous body. One of the early copies was identified as "Kaloma," copyrighted by the Pastime Novelty Company in 1914. The photo continues to be identified with Josie. (Author's collection.)

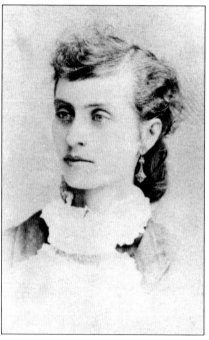

(*left*) Louisa Houston Earp, a direct descendant of Sam Houston, was a woman of extreme beauty with large luminous eyes. She met Morgan Earp in Dodge City and became his common law wife. She accompanied Morgan's casket back to the Earp family home in Colton, California, after his assassination. She wrote her sister, "It is quite impossible to tell you all the trouble and anxiosisty [*sic*] in which the Earp family has found itself." (Courtesy Glenn Boyer.)

Alvira "Allie" Packingham Sullivan met Virgil Earp while she worked as a waitress in Council Bluffs, Iowa, and he was driving a stagecoach. He soon brought her to Tombstone. Allie tried to read the future with cards and when five black spades appeared, Virgil remarked, "Five brothers, all dark and handsome like me! That's what you married into, Allie! A spade flush!" Allie described Tombstone as "like living at the foot of the Tower of Babel." (Courtesy Glenn Boyer.)

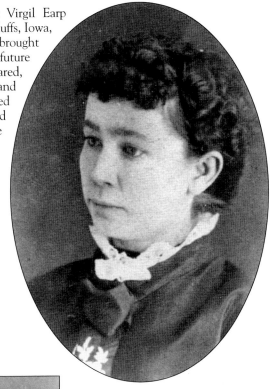

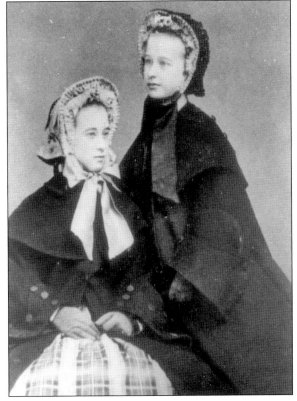

Seated next to her sister is Big Nose Kate, Doc Holliday's woman, as she looked in 1867 when she ran away from home in Davenport, Iowa. Her father, a Hungarian immigrant, had been a surgeon for Maximilian in Mexico. Born Mary Katherine Haroney, she took the name Kate Fisher and stowed away on a Mississippi River steamer sometime before 1867. She met Doc and Wyatt in Dodge City in 1876 but did not like the Earps and tried to get Holliday to sever his relationship with them. (Courtesy Glenn Boyer.)

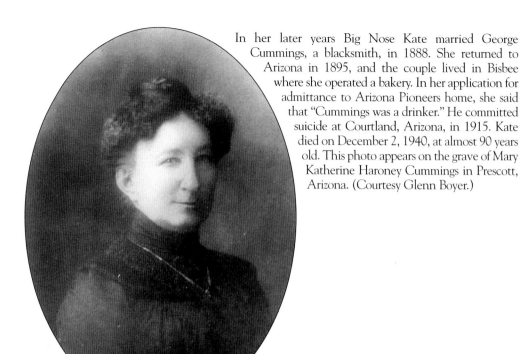

In her later years Big Nose Kate married George Cummings, a blacksmith, in 1888. She returned to Arizona in 1895, and the couple lived in Bisbee where she operated a bakery. In her application for admittance to Arizona Pioneers home, she said that "Cummings was a drinker." He committed suicide at Courtland, Arizona, in 1915. Kate died on December 2, 1940, at almost 90 years old. This photo appears on the grave of Mary Katherine Haroney Cummings in Prescott, Arizona. (Courtesy Glenn Boyer.)

Celia Ann "Mattie" Blaylock is perhaps the saddest story of the Earp women. She was Wyatt's common law wife until he took up with Josie Marcus. Mattie ended up as a prostitute near Pinal, Arizona, where she drank and took laudanum to sleep. On July 3, 1888, she was found dead with empty whiskey and medicine bottles near her bed. (Courtesy Ben Traywick.)

In September 1873, dentist John Henry Holliday, at age 22, left Atlanta, Georgia, on a train bound for Texas in hopes that a dry climate would cure his tuberculosis. He would not be able to practice his profession as long as he had the tubercular cough. This photo was taken on March 1, 1872, to commemorate his graduation from the Pennsylvania College of Dental Surgery. His travels took him from Denver to Dodge City and eventually to the Arizona Territory where he participated in the Tombstone gunfight. (Courtesy Glenn Boyer.)

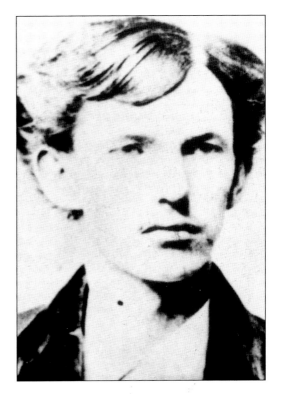

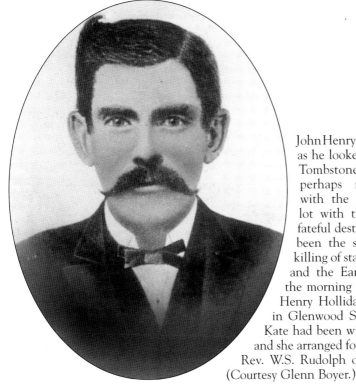

John Henry "Doc" Holliday is shown here as he looked at the time of the famous Tombstone gunfight. Doc Holliday, perhaps recalling past friendship with the Earps, decided to cast his lot with them as they went to that fateful destiny. Holliday had previously been the subject of gossip about the killing of stagecoach driver Bud Philpott and the Earps had stood by him. On the morning of November 8, 1887, John Henry Holliday died at Hotel Glenwood in Glenwood Springs, Colorado. Big Nose Kate had been with him during his last days, and she arranged for a service to be delivered by Rev. W.S. Rudolph of the Presbyterian Church. (Courtesy Glenn Boyer.)

Newman H. "Old Man" Clanton—a rancher, farmer, and cattle rustler—was born in Tennessee and lived in Missouri, Texas, and California before settling on a ranch near Charleston. His four sons included Joseph, Isaac, William, and Phineas, and he employed Johnny Ringo and William "Curly Bill" Brocius. Five cowboys, including Old Man Clanton died in a raid on Mexican smugglers led by Miguel Garcia in the Peloncillo Mountains. The Clantons provided meat for Tombstone, most of which came from ranches other than their own. (Courtesy Arizona Historical Society.)

Joseph Isaac "Ike" Clanton operated a restaurant and lodging house near Millville on the east bank of the San Pedro River. Usually Ike could be found gambling and drinking in one of the many saloons around Tombstone. He played a part in the festering gunfight when Wyatt Earp tried to get him to set up some of his friends for a stage robbery. When the fight broke out, Ike fled and his brother Billy was killed. On June 1, 1887, Ike was killed for cattle rustling in Apache County. (Courtesy Arizona Historical Society.)

Robert Findley "Frank" McLaury (also spelled McLowery) was killed in 1881 in the gunfight at the O.K. Corral. Frank was born near Oneonta, New York, and raised on a farm in Hazelton, Iowa. Although he ran with a rough crowd that shot up saloons and rustled cattle he was never convicted of any serious crime. In one version of the gunfight, Frank was ready to leave town when he fell from his horse and was mortally wounded. He gamely returned fire, wounding Virgil Earp in the arm and leaving it useless for life. (Courtesy Ben Traywick.)

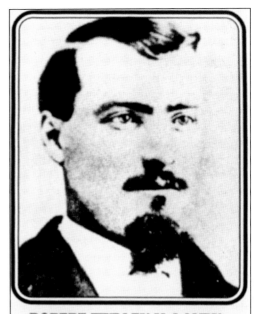

ROBERT FINDLEY McLAURY
Killed, 1881, in the
Gunfight at the O.K. Corral.

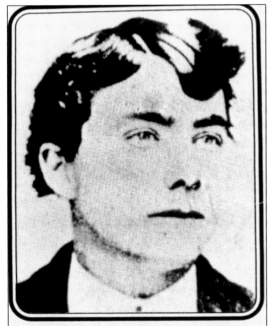

THOMAS CLARK McLAURY
Killed, 1881, in the
Gunfight at the O.K. Corral.

Thomas Clark McLaury's beginning and end of life were much the same as his brother Frank. Tom is supposed to have had his hands up when a load of buckshot from Doc Holliday cut him down. Sheriff Behan testified that Ike Clanton and Tom McLaury were unarmed. John P. Gray said, "I saw the battle. The Earps called out, 'Hands Up!' and fired almost simultaneously." (Courtesy Ben Traywick.)

55

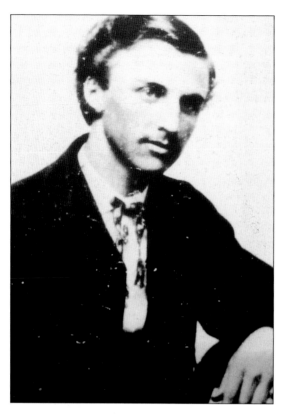

William Floyd Claiborne, also known as "the Kid," was born in Louisiana on October 21, 1860. He came to Arizona with John Slaughter and worked at the mines at Charleston and Hereford before he fell into company with the cowboy element. On October 1, 1881, he killed Jim Hickey in a saloon brawl; he almost got involved in the famous gunfight with the Earps but backed out at the last minute. On October 14, 1882, he got in an argument with the Oriental's bartender Frank Leslie. Leslie threw him out and Parsons reported that Leslie made as "pretty a center shot on the Kid as one could wish to." (Courtesy Ben Traywick.)

Frank C. Stillwell was born c. 1855 and grew up in Iowa City, Iowa. He arrived in Arizona around 1877 and worked as a teamster for Ham Light near Charleston. He worked in a saloon, sold liquor wholesale, and Sheriff Behan appointed him a deputy sheriff. He was implicated in a number of shootouts and accused of murdering Morgan Earp. On March 20, 1882, Frank Stillwell's body was found near Tucson railroad tracks riddled with bullets. The coroner listed the Earps, accompanying Morgan's body to California, as the guilty parties. (Courtesy Ben Traywick.)

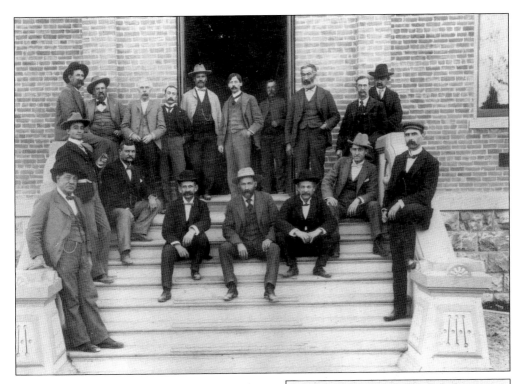

Robert Paul stands at the far left at the bottom of the stairs with a group of Pima County lawmen. Born in Connecticut, Paul followed the 1849 gold rush to California but he never found his fortune. He moved to Arizona and rode shotgun for Wells Fargo on the Tucson-Tombstone route. In March 1881 a group of bandits held up the stagecoach and killed a passenger and the driver Bud Philpott. When the bandits shouted, "Halt!" Paul yelled, "I hold for no one!" He grabbed the reins and fired at the bandits. Paul went on to serve in several law-enforcement capacities, including Pima County sheriff. (Courtesy Arizona Historical Museum.)

The Earps and Paul did not feel that Sheriff Johnny Behan did enough to bring the bandits to justice. As an official of Wells Fargo, Paul created a wanted poster for four men, which was not to be posted but rather was to be placed in reliable hands. All four men died by the bullet. (Author's collection.)

Don't post, but place in the hands of discreet and reliable persons only.

$3,600 00 REWARD.

ARREST THE MURDERERS!

About 9 o'clock Tuesday evening, March 15, 1881, the stage bound from Tombstone to Benson was attacked by three men armed with Winchester rifles, at a point about two miles west from Drew's stage station, and Budd Philpot, the driver, and Peter Roerig, a passenger, shot and killed.

The attack was no doubt made for the purpose of robbery. The Territory and Wells. Fargo & Co. have a liberal standing reward for the arrest and conviction of persons robbing or attempting to rob the Express. In addition, the Governor and Wells, Fargo & Co. have each offered $300 for the arrest and conviction of each of the murderers of Philpot and Roerig, so that the rewards now offered amount to $1,200 or $1,400 each.

It is believed that the attempted robbery and murders were committed by Bill Leonard, Jim Crain and Harry Head, described as follows:

BILL LEONARD.

American; about 30 years old; about 5 feet, 8 or 9 inches high; weight, 120 lbs.; long, dark, curly hair, when cared for hanging in ringlets down to shoulders; small, dark, boyish mustache, otherwise almost beardless; teeth very white and regular; dark eyes; small, sharp and very effeminate features; rather weak voice; left arm full of scars caused by injecting morphine; is subject to rheumatism; chews tobacco incessantly; speaks good Spanish; good shot with rifle and pistol; a jeweler by trade; is known in Silver City, Otero and Los Vegas, N. M.

JAMES CRAIN.

American; about 27 years old; about 5 feet, 11 inches high; weight, 175 or 180 lbs.; light complexion; light, sandy hair; light eyes; has worn light mustache; full, round face, and florid, healthy appearance; talks and laughs at same time; talks slow and hesitating; illiterate; cattle driver or cow-boy.

HARRY HEAD.

About 18 or 20 years old; 5 feet, 4 or 5 inches high, weight, 120 lbs.; chunky and well built; dark complexion; dark hair and eyes; rather dandyish; almost beardless; small foot and hand; good rider, and handy with rifle and pistol.

All mounted, and well armed with rifles and pistols, and the last trace of them they were going toward San Simon Valley.

If arrested, immediately inform Sheriff Behan and the undersigned by telegraph at Tombstone, A. T.

R. H. PAUL,
Special Officer of W., F. & Co.

Tombstone, A. T., March 23, 1881.

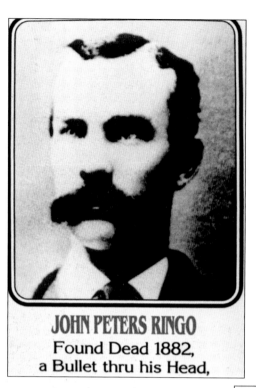

JOHN PETERS RINGO
Found Dead 1882,
a Bullet thru his Head,

John Peters Ringo was found dead at Turkey Creek Canyon in the Chiricahua Mountains in 1882 with a bullet through his head. Ringo was born around 1850 in Wayne County, Indiana. After his father committed suicide, Ringo's mother and family traveled to California. He served as a constable in Mason County, Texas, and came to Arizona with another Texan in 1879. He became involved with Tombstone's cowboy element and was involved in a few saloon brawls. Ringo was found dead, straddling a tree with one shoe off. His death poses a mystery for many historians—the coroner called it suicide but any man in the vicinity who owned a gun was a suspect, including the Earps and Doc Holliday. (Courtesy Ben Traywick.)

John H. Behan was born in Missouri on October 25, 1845. This photo shows Behan as a sheriff of Yavapai County in 1871. He divorced while in Prescott and in late 1880 headed for Tombstone. Here he confronted Wyatt Earp—both men wanted to be the new sheriff of the soon to be created Cochise County. Wyatt stood the better chance because both he and the territorial governor were Republicans. Behan and Earp worked a deal: if Behan became sheriff, which he did, he would appoint Earp as deputy sheriff, which he did not. At the same time Josephine Marcus, who had been living with Behan, switched her affections from Behan to Earp. After the Tombstone debacle, Behan served as superintendent of Arizona State Prison at Yuma. Behan died on June 7, 1912. (Courtesy Sharlot Hall Museum.)

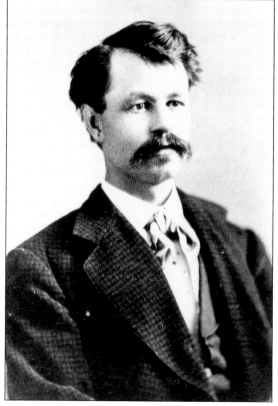

William Herring, a native of New Jersey, was born in 1833. He served as a deputy district attorney in New York before coming to Arizona in 1878. He had intended to close his brother's estate, including the Neptune Mining Company at Bisbee, but he stayed the rest of his life. Herring acquired several mining properties in the Tombstone area, and he also successfully defended the Earps and Holliday when they were charged with the murder of Tom and Frank McLaury and Billy Clanton. (Courtesy Ben Traywick.)

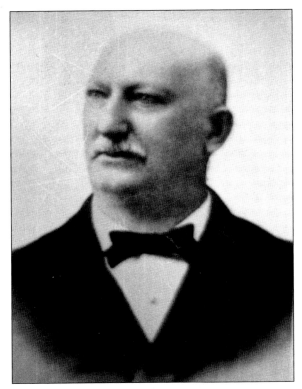

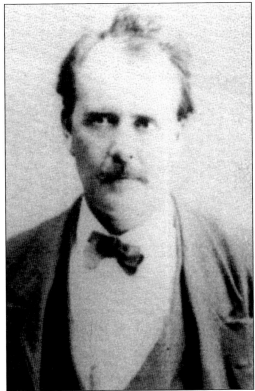

Judge Wells W. Spicer presided over two important legal cases during his career. He was at the 1875–1876 trial of John Doyle Lee for the 1857 murders at Mountain Meadows, Utah. He also served at the inquest convened at Tombstone in 1881 to determine if the Earp brothers and Doc Holliday should be brought to trial for the murders of Bill Clanton and Tom and Frank McLaury. In his decision Spicer found the evidence insufficient to warrant holding the defendants for trial and they were released. On April 13, 1887, the *Arizona Daily Star* reported that Spicer had visited Covered Wells, Arizona, and had made two attempts to commit suicide but was prevented by Bill Haynes. Wells was presumed to have drowned in 1881. (Author's collection.)

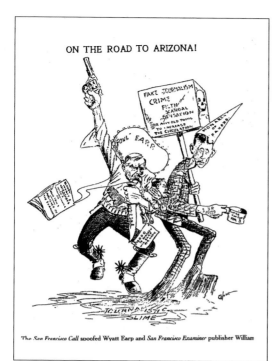

ON THE ROAD TO ARIZONA!

The San Francisco *Call* spoofed Wyatt Earp and San Francisco *Examiner* publisher William

The gunfight at the O.K. Corral received national attention, most of it not helpful to the territory's desire to achieve statehood. President Chester A. Arthur ordered Arizonans to cease "aiding, abetting, countenancing or taking part in illegal proceedings." (Author's collection.)

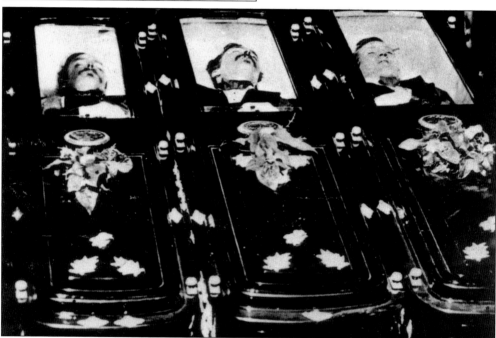

Billy Clanton and Tom and Frank McLaury lay side by side at the morgue covered with a sheet. Only young Billy Clanton's face showed the pain of dying. On October 28, 1881, the bodies were placed in handsome caskets with heavy silver trimmings. Photographs were taken of the corpses and a procession headed by the Tombstone brass band played the march of the dead. The first wagon contained the body of Billy Clanton and the second held the McLaury boys. Friends and relatives followed the bodies to their final resting place in Boothill. (Author's collection.)

Five

TOMBSTONE'S ENTERTAINMENT TONIGHT

From its inception Tombstone demanded entertainment. The *Arizona Daily Star* reported on March 1879 that Billy Brewster's Minstrels were elated with their trip to Tombstone. Miss May Belle, who played Cousin Hebe in the *H.M.S. Pinafore*, was better known as Josephine Sarah Marcus, who later became the third Mrs. Wyatt Earp. Tombstone's most celebrated theater, the Bird Cage Theatre, offered gambling, liquor, vaudeville entertainment, and ladies of the night. In 1882, the *New York Times* referred to the Bird Cage as, "the Roughest, Bawdiest, and Most Wicked Night Spot between Basin Street and the Barbary Coast." Ladies of the night plied their trade in cribs suspended from the ceiling. Schieffelin Hall offered legitimate theater to the more genteel class. When Tombstone's boom turned to bust in 1889, the Bird Cage was sealed and boarded up with all its furnishings intact. For the first Helldorado celebration in 1929 it reopened as a unique historic landmark with all the fixtures, furnishings, and gambling tables dating from its boom town days. Schieffelin Hall and the Bird Cage are all that remain of the several theaters that flourished in Tombstone's boom times.

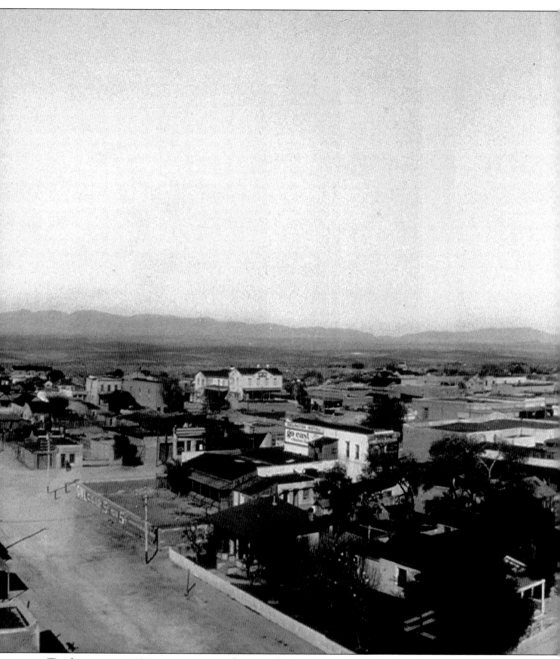

Tombstone *c.* 1909 was very much a settled community. The handsome two story white building to the left is Schieffelin Hall. The town was going through economic difficulties

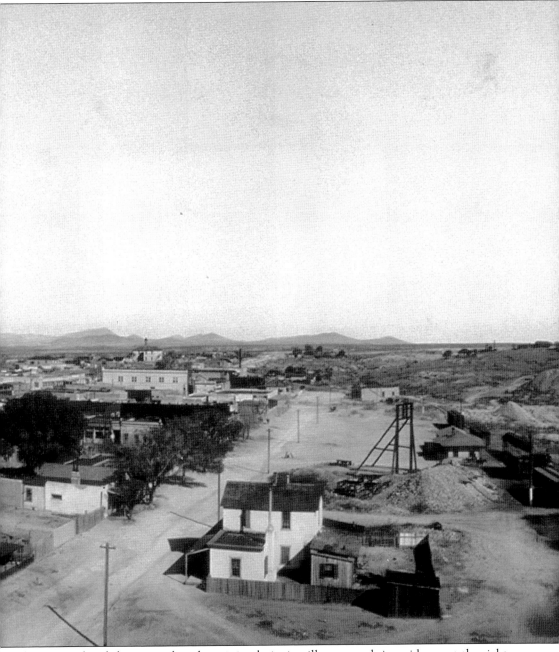

after water closed the mines, but the mining hoist is still very much in evidence at the right. (Author's collection.)

✳ TOMBSTONE'S THEATRES ✳

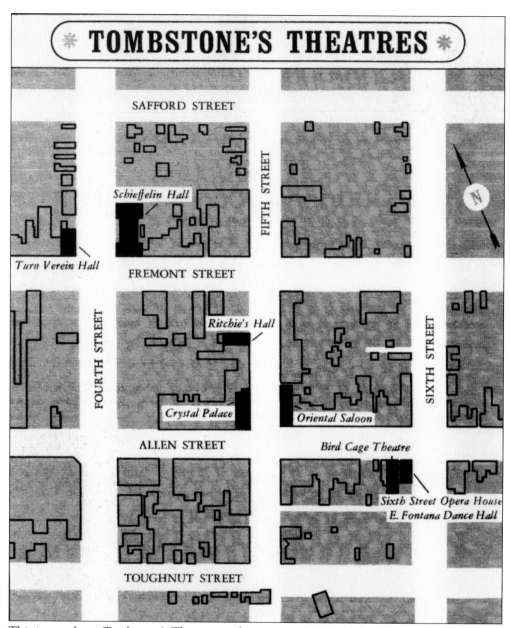

This image shows Tombstone's Theaters as they appeared after the boom times.

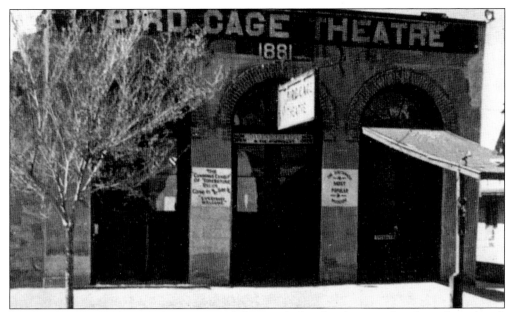

Shortly after the Bird Cage Theatre opened, lyricist Arthur Lamb pointed to the cribs and said, "Those women are like birds in a gilded cage." Eddie Foy replied, "Sounds like a title to a song." In 1900, Lamb gave the lyrics "She's Only a Bird in a Gilded Cage" to Harry Von Tilzer for musical arrangement. Lamb gave the song to a beautiful female singer at the Bird Cage, who sang the song to a roaring crowd that brought her back for several encores. After the famous singer Lillian Russell sang "She's Only a Bird in a Gilded Cage," it became one of the most popular songs of the 19th century. (Author's collection.)

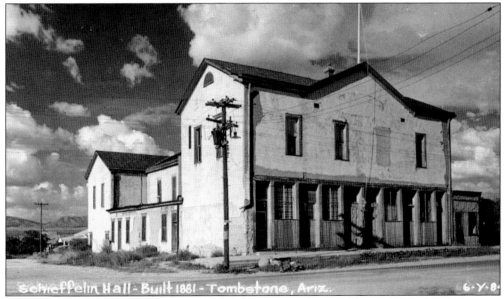

Schieffelin Hall, constructed in 1881, was a two-story adobe building with a seating capacity of 700 and a 40-feet-wide stage. It was also the home of the King Solomon Lodge of Free and Accepted Masons. The *Arizona Daily Star* described the Colorado scene on the drop curtain as a work of art. (Author's collection.)

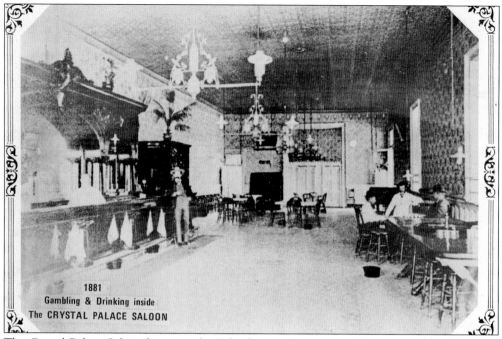

1881
Gambling & Drinking inside
The CRYSTAL PALACE SALOON

The Crystal Palace Saloon began as the Wherfritz Building where Deputy U.S. Marshal Virgil Earp had his office facing Allen Street. Later the name was changed to the Fredericksburg Lager Beer Depot, which served a delicious free lunch provided the customer bought and drank beer with the meal. The owners decided to give the place a touch of class by importing and using crystal stem-ware; they changed the name to the Crystal Palace Saloon. (Author's collection.)

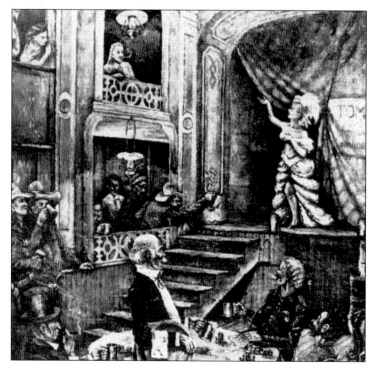

The interior of the Bird Cage Theatre is shown here in a painting by Ross Stefan. Described as a "one-stop sin shop," the Bird Cage provided entertainment, good whiskey, tolerable water, and wild women. William J. Hutchinson, a co-manager of Tombstone's Sixth Street Opera House and a vaudeville performer, purchased the site for $600 in 1880. By the end of 1881, construction of the Bird Cage was completed, and on December 23, its doors opened to the public. (Author's collection.)

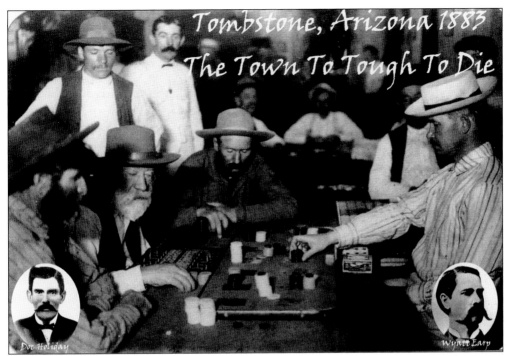

Doc Holiday

Wyatt Earp

Every Tombstone saloon had roulette wheels along with faro and poker tables, and the games went on 24 hours a day, 7 days a week. They parted cowboys and soldiers from their pay, miners from gold dust, and those who happened to be in town from their savings. The gambling business was to enrich the saloon keeper, his stable of soiled doves, and the professional gamblers. If the gambler had to use lead, he so did with the intention to kill: a wounded man might return to avenge hurt feelings. (Author's collection.)

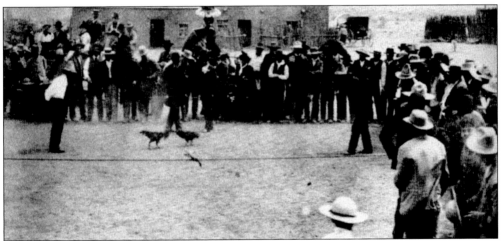

Cock fights, a "sport" imported from Mexico, provided entertainment in early Tombstone. Hundreds of dollars were bet on a favorite rooster. The referee announced the contestants and their past records, then the "setter-to," or manager, of each cock brought his rooster into the pit. At the appropriate signal each man placed his bird on the ground. The roosters would jump at each other and draw blood with their spurs. At the death of a bird from loss of blood the other was pronounced the victor. (Author's collection.)

Nellie Boyd, the first dramatic actress to appear in Tombstone, opened with *Fanchon, the Cricket* at Ritchie's Hall. Tombstone newspapers lauded the versatile actress, who claimed to have run away from a convent to seek a career on stage. In her audience on December 4, 1880, "there were 10 men who had shotguns loaded in ready if needed in case land speculators James Clark and Mike Gray appeared." Mayor Alder Randall had conveyed the Tombstone townsite to Gray and Clark without permission from the town council. (Courtesy New York Public Library.)

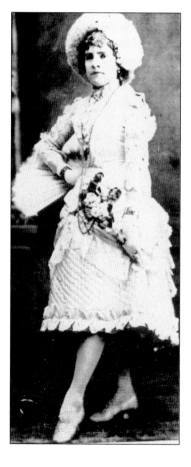

Nola Forrest, described as a premier danseuse at the Bird Cage, caused quite a stir in Tombstone with her amorous adventures. Her ardent fan, bookkeeper J.P. Wells, embezzled $800 to keep his lady love in jewels. Subsequently Nola made up with her husband, Billy, and the couple left Tombstone for Tucson and Colorado. Wells subsequently took up with another woman. He drowned in the Gila River in 1881. (Courtesy New York Public Library.)

Magician and showman Charles "Uncle Charlie" Andress had performed in rough western mining camps since he was 12. His shows included the *Performing Fleas* and the *Learned Pig*. He got quite a start when, during a performance of *Uncle Tom's Cabin*, a drunk cowboy shot one of his bloodhounds chasing the character Eliza across a river. When the cowboy sobered up, he was properly penitent and cried over the dead dog. Years later, Andress, the proprietor of the Andress Carnival of Novelties and Trained Animal show, recalled that the cowboy offered him his money and horse in recompense. (Author's collection.)

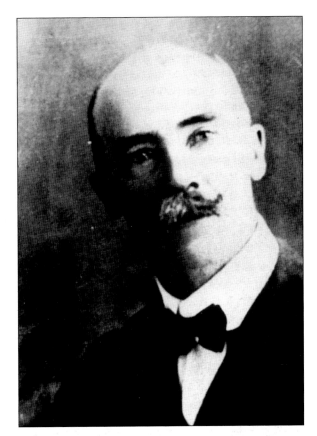

Frederick Warde toured the American West with his Shakespearean group. After checking on advance ticket sales he cancelled his Tombstone engagement in 1885 rather than perform at a loss. (Courtesy New York Public Library.)

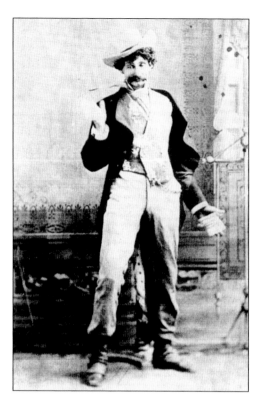

The great vaudeville actor Eddie Foy was born Edwin Fitzgerald on March 9, 1856, in Greenwich Village, New York, and died on February 16, 1928, in Kansas City, Missouri. In Dodge City his habit of poking fun at the rough miners, gamblers, and gunfighters got him doused in a horse trough. His immediate return to the stage endeared him to the audience and after that he could do no wrong. Eddie Foy's repertoire included poverty-inspired Irish two-acts and lavish musical comedies. His indigent childhood in New York's Bowery and in Chicago toughened him for the uphill climb as a vaudeville artist at Western outposts such as Tombstone. (Courtesy New York Public Library.)

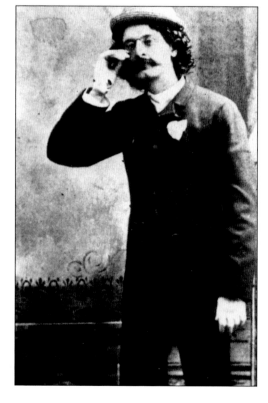

After the death of Eddie Foy's wife, the ballerina Madeline Morando, he put his seven children, four boys and three girls, into his act so he could retain custody. They became known as the Seven Little Foys. When his son Bryan visited Tombstone in the 1930s he recalled with nostalgia the days they had spent there and almost bought the entire town. Eddie Foy viewed the western stage as an escape essential for men who spent grueling days in the blistering sun. (Author's collection.)

Bones Brannon grew up in Tombstone, the son of a jerk-line driver for 24-mule teams. Gambling was considered a legitimate profession and Bones believed that he was born to deal the bank. He felt that a public school education was a waste of time. He dealt his first game from a faro box that he made out of an old cigar box. He took up with a woman known only as Della, and by age 22, Bones had become an expert dealer. Drinking and heavy losses put him in jail and at work on the chain gang. Bones took Della and found work in the Bisbee's saloon. Before long they headed for Nevada's boom at Tonopah. (Author's collection.)

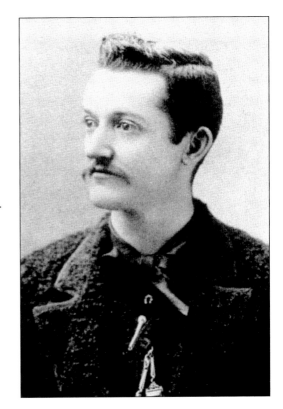

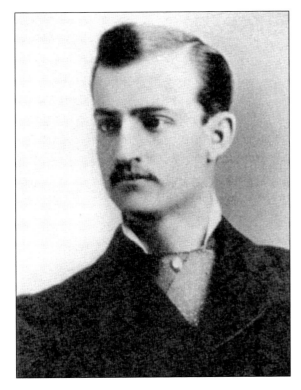

Johnny Bauer, also known as "The Dutch Kid," was as handsome a man as ever graced a Tombstone faro table. He was paid $25 for a six-hour shift. After six hours, gamblers tended to get tired and careless, and they might make the kind of costly mistakes that could cost them their money or their lives. The games, run with a highly flexible code of ethics, were as crooked as the house could get away with. Thus the gamblers would display a .45, and keep a smaller gun, known as a pepper box, on their person, or under the table where it could be easily fired. (Author's collection.)

Johnny Speck, shown here with his son Johnny, was a co-owner of the Crystal Palace. From time to time he would deal cards himself. During Tombstone's heyday 14 faro banks advertised that they never closed—a man could lose his money any time he pleased. (Courtesy Ben Traywick.)

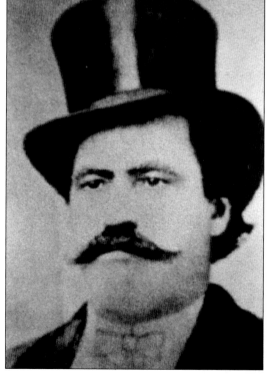

"Rowdy Joe" Lowe ran a dance hall and he could take care of obstreperous customers. He was well known around town for starting and finishing his own fights. Bat Masterson considered Rowdy Joe amongst the most proficient gunfighters because of his expertise with a pistol, careful deliberation, and cool assessment of a dangerous situation. (Courtesy Ben Traywick.)

Tombstone remembered him only as "The French Count"—French he was but a count he probably was not. This man pimped for the madams of the French bawdy houses; each month he brought in new girls and took the old ones to different locations. He also collected a percentage of the money. He appears to have had connections in most of the western mining camps. He was often heard to argue loudly, but the arguments were always in French and no one in Tombstone knew whether they were serious or not. (Courtesy Ben Traywick.)

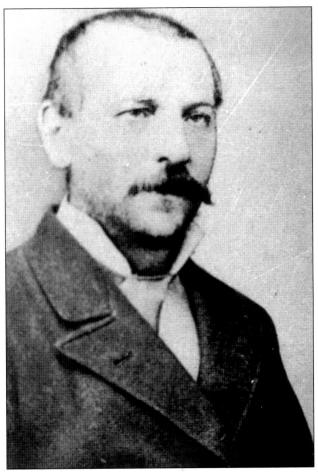

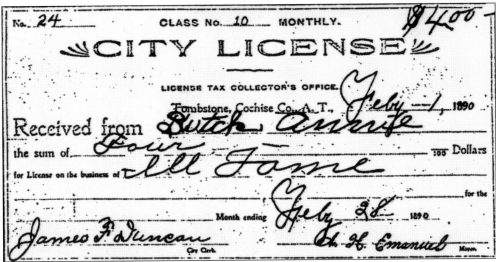

Each madam had to pay $4 a month to run a house of ill fame in Tombstone. Dutch Annie had her license signed by James Duncan, the city clerk, and Mayor Abraham Emanuel. (Author's collection.)

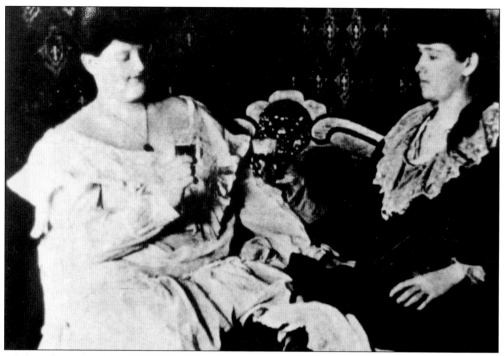

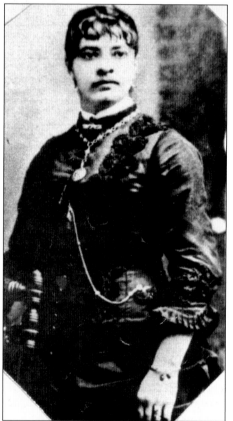

The soiled doves of Tombstone relax with sewing and chatting before going to work from noon until dawn. Most of the houses had a standard fee of $10 for a session and around $25 for an overnight. Exceptionally beautiful women and women who possessed special skills could command higher prices. The girls had one day a week off. In Tombstone the girls were required to bathe at least three times a week. (Courtesy Ben Traywick.)

Crazy Horse Lil was a big, tough madam. Most of Tombstone's houses of ill repute tried to give an aura of refinement, but this did not apply to wherever Crazy Horse Lil worked her trade. She liked to get roaring drunk and fight with her man, Con O'Shea. Fights kept her in jail much of the time. She and Con finally left Tombstone for the new mining camp at Lowell, where she became the madam of a large house and lived in high style. She is credited with saying, "The wages of sin are a damn sight higher than the wages of virtue." In Lowell, Crazy Horse and Con staged robberies of their own house. It was a while before anyone caught on to the fact that they were getting 50 percent of the take and that the goods were being returned to them. (Courtesy Ben Traywick.)

In 1886, Joe and Maulda "Big Minnie" Bignon took over the Bird Cage. Joe had been a minstrel and circus performer before settling in Tombstone around 1882. Tombstone newspapers acclaimed him as an excellent clog dancer. On May 5, 1889, he married pianist and dancer Maulda Bouton. The Bird Cage usually featured variety performances, but Joe also staged wrestling and boxing matches. He left Tombstone briefly and operated a theater in Phoenix. He returned to Tombstone where he operated a theater and dealt in real estate and mining properties in the Dragoon Mountains until his death on December 6, 1925 at 85. (Author's collection.)

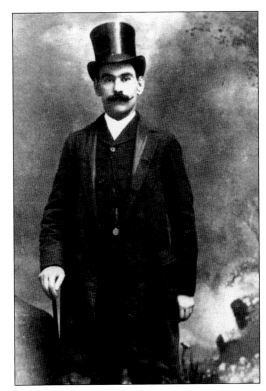

Maulda "Big Minnie" Bignon stood six feet tall and weighed well over 200 pounds. Minnie had a sweet personality and a big heart, but she also acted as a bouncer. The *Prospector* in 1889 reported that a Mexican woodchopper laid a wooden nickel on the bar and expected a whiskey. The barkeep expressed displeasure and a fight ensued. Some offered to fetch the sheriff to toss out the woodchopper, but Minnie said, "Why bother? I'll put him out myself." With those words and a hammerlock, the woodchopper found himself out on the street. Minnie frequently put on a dance in pink tights that always drew a huge ovation. Big Minnie died on August 6, 1900. (Author's collection.)

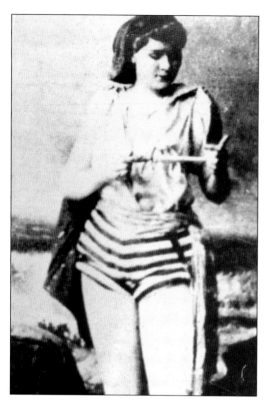

May Davenport, who came to Tombstone as carnival girl, is one of the few working girls who left us her last name. She worked in Tombstone as a prostitute before opening her own house, May's Place, in Cananea, Mexico, a short distance south of the border. Cananea experienced a mining boom and a nice parlor house was in order there. (Author's collection.)

Blonde Marie was a French madam and got her girls from the Count. The ambience of her house was more refined than most. Blonde Marie had no bar so there were no drunken fights. If someone needed a bottle she would send out for it but never took a drink herself. She was picky about her customers, serving only big mining and cattle men. During her period in Tombstone she made trips back to France and returned with new girls and new clothes. In the 1890s Blonde Marie packed her clothes and jewels, boarded a stage coach and set sail for France for the last time. (Courtesy Ben Traywick.)

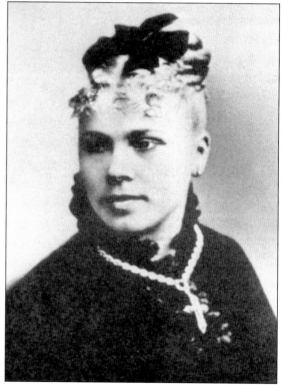

Dutch Annie, like many others in her profession, took on a name that reflected her physical characteristics. Like many of the madams, Dutch Annie would frequent the gambling tables and like to "buck the tiger" (go for broke). If she lost, well, there were always *other* ways of getting her money back. She was also an angel, if somewhat fallen, and she helped Tombstone with money during hard times. When Dutch Annie died no one knew her real name but Tombstone turned out en masse to bury her in Boothill with dignity. More than a thousand buggies followed her to her final resting place. (Courtesy Arizona Historical Society.)

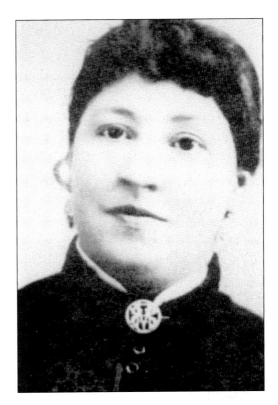

Esmarelda arrived in Tombstone after a stint in Virginia City. When Tombstone fell on hard times, she moved on to Rawhide. (Courtesy Ben Traywick.)

Emma (or Cora) Davis became one of the most famous madams of Tombstone. She was 35 years old when she arrived in Tombstone and she was still handsome and had fine manners. Her girls were far above average in appearance and many were accomplished musicians. Davis insisted on total honesty in her dealings. If a customer got too drunk, his valuables were taken and he received a receipt for them. When he left, his personal possessions were returned to him. (Courtesy Ben Traywick.)

Mary (or Marce) Dupont was another Tombstone madam. (Courtesy Ben Traywick.)

Six

THE LAW AND
THE OUTLAW

Cochise County, named for the famous Apache warrior, was carved out of the southeast corner of Pima County on February 1, 1881. The county area covers a little more than 4 million acres and is the equivalent size of Connecticut and Rhode Island combined. The new county started out with so much trouble that the governor threatened to declare martial law. The booming silver mining town of Tombstone won the county seat over its contenders, Bisbee and Willcox. Although the most famous fight was the Earp-Holliday vs. Clanton-McLaury gunfight at the O.K. Corral, the fledgling county and Tombstone had many gunfights that were equally interesting but not as well known. People, often for good cause, did not think too much of early Tombstone justice. A story is told of the cowboy, accused of murder, who paid an Irishman on his jury to vote for manslaughter. He got his verdict and asked the Irishman, "Did you have a hard time convincing the jury?" The juror replied, "I did indeed. They wanted to acquit you." From its inception, Cochise County was plagued with cowboy gangs, mainly cattle thieves who had been run out of Texas and New Mexico and found refuge in the rugged mountains of Arizona. They stole, murdered, and committed mayhem at will on both sides of the United States-Mexico border. The Clantons, the McLaurys, Johnny Behind the Deuce, Johnny Ringo, Curly Bill Brocius, Buckskin Frank Leslie, Billy Claiborne, Burt Alvord, and other infamous outlaws have passed into the annals of Cochise County history.

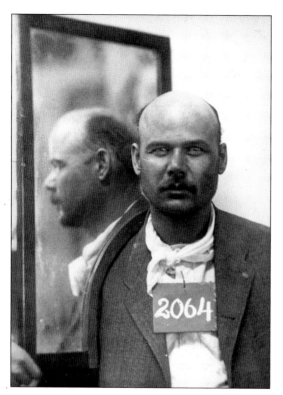

Albert "Burt" Alvord has his picture taken as he enters the Arizona Territorial Prison at Yuma on March 4, 1904. He was released on October 5, 1905. Alvord served as Sheriff John Slaughter's deputy and tried ranching and mining with no success. He became a train robber with Billy Stiles, Matt Burts, and Bill Downing. One day, Alvord and Matt Burts went to Bisbee on a pleasure trip. Before returning, they sent the editor of the *Epitaph* a telegram reading, "Bodies of Burts and Alvord will arrive this afternoon." The reporter met the stage expecting to see two caskets. Instead, Burts and Alvord got off and, smiling broadly, Alvord said, "Sure our bodies arrived. We never go anywhere without them." Alvord was troublesome, but there was enough humor in his escapades to make people forgive him. Alvord's end is murky; there is a report that he died on July 22, 1910, of fever in Barbados. (Courtesy Harold Edwards and Yuma Territorial Prison.)

William "Bill" Downing is photographed on his entry to the Yuma Territorial Prison on April 9, 1901. He was released on October 8, 1907. Alvord, Burts, and Three Fingered Jack Dunlap teamed up with a mean no-good from Casa Grande named Billy Stiles and another ne'er-do-well from Willcox, Bill Downing. On the evening of September 11, 1899, they held up a passenger train near Cochise. The robbers had dynamite stashed nearby and they blew up the safe. Express messenger Frank Milton was wounded, but he shot Three Fingered Jack Dunlap in the leg. Dunlap, left to die in the desert by his cohorts, was found by a posse and taken to a Tombstone hospital, where he gave lawmen the names of the rest of the outlaws before he died. Downing did not repent his ways and was shot in a Willcox saloon on August 5, 1908. (Courtesy Harold Edwards and Yuma Territorial Prison.)

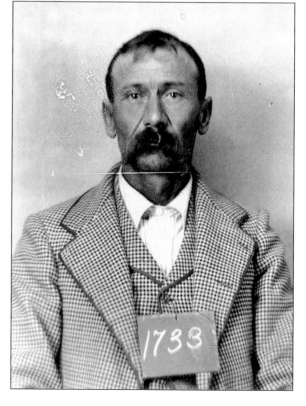

Matt Burts entered the Yuma Territorial Prison on December 14, 1900, and was released on April 8, 1901. When word of the train robbery got to Willcox everyone went looking for Constable Alvord. They found him at Schweitzer's Saloon in a card game with Billy Stiles and Matt Burts. Upon hearing of the train robbery, Alvord broke up the game and deputized Stiles and Burts. This unholy trio was supposed to bring law and order. Someone spoke up and said Alvord, Stiles, and Burts had not been in the saloon the entire evening. Sheriff Scott White became suspicious, and before long Alvord and Downing were in jail, along with George and Frank Lewis, who were thought to be part of the gang. Burts was caught in Tucson and returned to Tombstone. White shot and arrested Thomas Yoas, also known as Bravo Juan, in Sonora. He was taken to Tombstone with a bullet in his leg. (Courtesy Harold Edwards and Yuma Territorial Prison.)

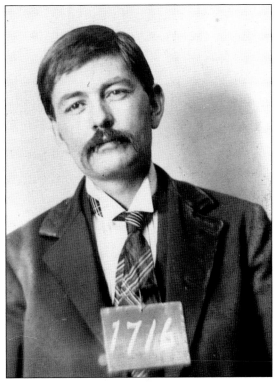

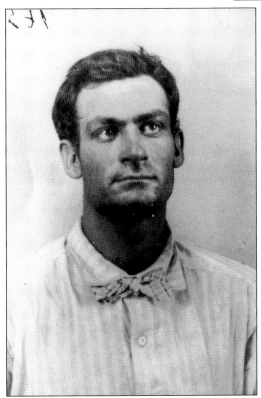

William Larkin "Billy" Stiles was incarcerated in the Yuma Territorial Prison on July 6, 1900, for "safekeeping" after he turned state's evidence in the Alvord-Stiles train robbery. In an action calculated to irritate Sheriff White, Stiles, and Alvord sent a letter, saying "Scott White, Esq. We send you the keys to the jail. We would have given them to Sid Mullen, but he was too swift for us, we could not overtake him. We met the Mexicans that killed the gambler in Johnson Camp but as we had no warrants we did not arrest them—and we were afraid they would shoot, and we had no warrant and we couldn't collect mileage. Tell the boys we are all well and eating regular. Tell the man I got the Studebaker saddle and will send it home soon." The letter was signed Bravo Juan, Stiles, and Alvord. A few years later Stiles was serving as a deputy sheriff in Humboldt County under the name of William Larkin. He was shot to death on December 5, 1908, while trying to deliver a court summons. (Courtesy Harold Edwards and Yuma Territorial Prison.)

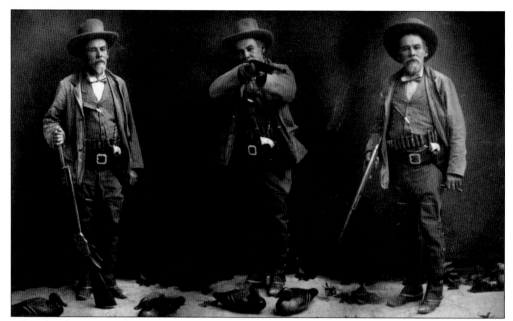

John Slaughter, a tough Texan, cleaned up Cochise County's lawless element by seldom bringing in a prisoner alive. Slaughter had soured on juries who turned bad men loose. He and Cyrus H. Bryant ran a close race for sheriff in 1886, but Slaughter won by a narrow margin. Slaughter was a former Confederate soldier and was about five feet, four inches, with piercing black eyes. He came to Cochise County from Texas in 1879, some say with a herd of rustled cattle. While Slaughter was sheriff, the supervisors allowed $28 for cuspidors for the courthouse and $666.65 for the care of smallpox patients. Citizens used their businesses as fronts and employed gun men to steal range cattle and ore from small mines. Van Wyck Coster, a business man by day, rode with rustlers at night. Juan Soto from Contention was another rough cutthroat. Slaughter got the goods on these men with the help of deputies, including Burt Alvord, who later turned outlaw. (Courtesy Arizona Historical Society.)

John Swain Slaughter, an ex-slave, came to Arizona with his former owner, Sheriff John Slaughter. He was born into slavery on June 23, 1845, near San Antonio. While Slaughter was out enforcing the law, he left the running of the ranch to Swain and another ex-slave known as "Old Bat." Swain bought a small ranch with his savings and raised a few animals and a vegetable garden. He became blind and died in the county hospital at Douglas on February 8, 1945. His last request was to be buried next to his old friend Quong Kee at Boothill. His body was escorted to the cemetery by Fort Huachuca's military. (Courtesy Ben Traywick.)

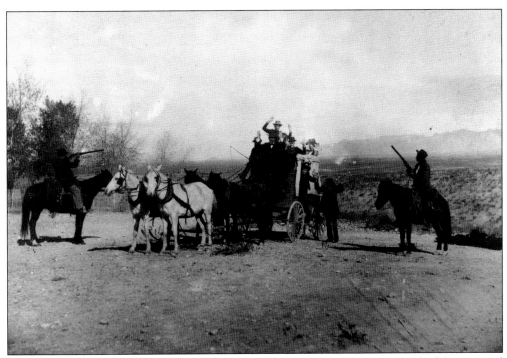

Tombstone liked to poke fun at itself, as is seen in this staged holdup. If it had been a real holdup, the horses would never have stood so still. (Courtesy Sharlot Hall Museum.)

Billy Stiles favorite newspaperman, George Smalley, performed a mock hold up in 1898. As a teenager, George H. Smalley served as editor of the Tucson *Citizen*. During his expose in the *Citizen* of a $10-million mining swindle, Smalley was shot at three times. However, Smalley criticized Cochise County Sheriff Del Lewis for handcuffing outlaw Billy Stiles. The outlaw resented Lewis for not accepting his word of honor. When the sheriff offered Stiles a beer, the outlaw smashed his fist in the sheriff's face. When Smalley heard that Stiles was hiding out near Tucson in 1898, he printed a notice in the paper asking the outlaw to come in and pose for him. Stiles agreed and the two men met behind Kurt Hart's gun shop. (Courtesy Arizona Historical Society.)

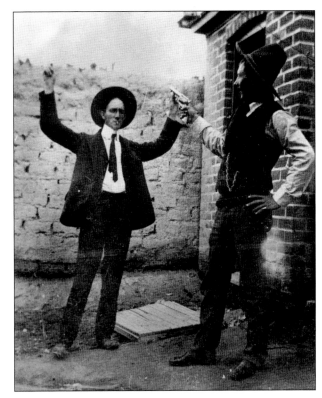

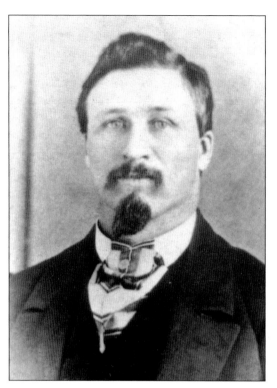

Cochise County sheriff Jerome Ward had the dubious honor of being tied up in the Tombstone Courthouse while many of his constituency lynched John Heith. Cochise County's first elected sheriff, Jerome L. Ward was born in Oneida County, New York, in 1833. His family moved to Wisconsin in 1843 where he farmed and served one year in the 1st Wisconsin Cavalry during the Civil War. In 1873, the Ward family moved to California, and five years later they moved to Arizona where Ward engaged in freighting. They moved again to Chicago for two years, but returned to Tombstone where Ward was elected sheriff as a "pronounced Democrat." After serving as sheriff, Ward was appointed guard at the Yuma Territorial Prison. In 1912, he moved to San Diego where, a year later, he was killed in a truck accident during a parade. (Author's collection.)

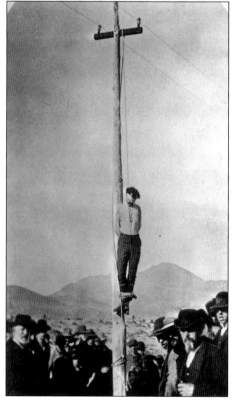

John Heith (Heath) hangs from a telegraph pole near Tombstone. On December 8, 1883, outlaws held up a store in Bisbee. The outlaws killed several men and shot Mrs. Roberts who died, along with her unborn child. The desperados took $600 and fled on horseback amid a fusillade of shots. When John Heith, who was drinking in a bar, tried to throw the posse off track, Deputy Billy Daniel became suspicious. He learned that the gang that committed the robbery and murder consisted of Red Sample, Bill Delaney, Dan Kelly, Dan Dowd, and Tex Howard and that their leader was John Heith. Heith got a life sentence but the other five were sentenced to hang. This outraged the people of Bisbee. On February 22, 1884, a vigilante committee tied up jailer Billy Ward, guard Jim Krigbaum, and Sheriff Ward, and removed Heith from his cell. Then they strung him up from a telegraph pole. (Courtesy Arizona Historical Society.)

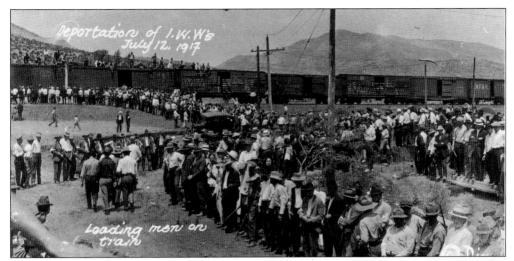

In 1917, the International Workers of the World (IWW) miners in Bisbee went on strike. With the United States involved in World War I many considered the strike treason. Cochise County Sheriff Harry Wheeler swore in 572 special deputies and, on July 12, 1917, 1,187 non-working miners along with their attorney, William B. Cleary, were arrested, loaded onto waiting cattle cars, and shipped to Columbus, New Mexico. The cattle cars were provisioned with bread and tepid water. At Columbus, the men were met by the U.S. 12th Cavalry, an all black contingent, who provided the strikers with tents, showers, latrines, and two meals of beans and hard-tack a day. (Courtesy Arizona Historical Society.)

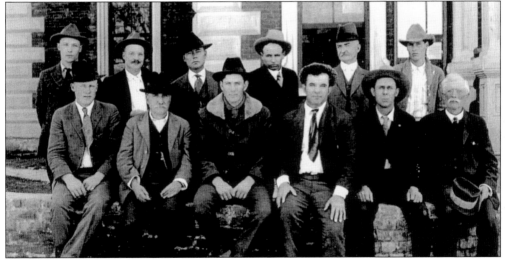

Robert Napoleon French, Cochise County attorney, swore out warrants for every deputy and several Phelps Dodge officials involved in the deportation of Harry Wheeler. Wheeler was brought back from France to stand trial for kidnapping. No convictions were secured because the deportation was represented as a war measure. The jury who heard the evidence in Tombstone included, from left to right (standing) Lee Holland, Apache; Andrew Mortenson, Douglas; John Jones, Sunnyside; Henry Richards, Hereford; W.L. Patterson, Benson; and Amos Gretton, Douglas; (seated) Frank Brown, Willcox; B.K. Riggs; Jesse Armstrong, Eldorado; Clifford ?, Jesse N. Curtis, Happy Camp Canyon; and J.O. Calhoun, foreman of the jury, Douglas. (Author's collection.)

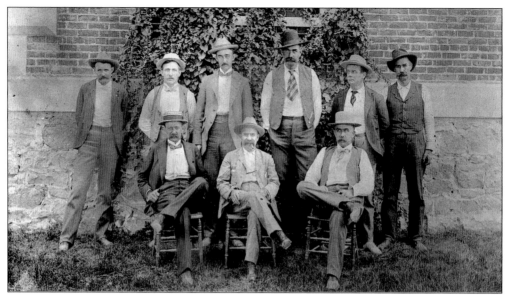

This photograph of the 1901–1902 Cochise County officers was taken in front of the Cochise County Courthouse in Tombstone. From left to right are (standing) Hugh Conlen, under-sheriff; William Hattich, editor and proprietor of the Tombstone *Prospector*; Cyrus W. Bestwick, probate judge; Del Lewis, sheriff; Ed Land, county attorney; and Jack Mathias, jailer; (seated) M.D. Scribner, treasurer; Abraham Emanuel, clerk of the court; and Tom York, chairman of the board of supervisors. (Courtesy Arizona Historical Society.)

Sheriff Del Lewis poses with his friends. From left to right are (standing) Dale Graham, a freighter; G.J. McCabe; and William Scott; (seated) Frank Johnson; Sheriff Adelbert "Del" Lewis; and Charles Locklin. Del Lewis stood six feet, six inches tall and weighed 260 pounds. When Lewis shut the iron-bar doors of the "Hotel Lewis" (a nickname for the Cochise County Jail) behind a new prisoner, the bailiff would boom, "Hear ye! Hear ye! The kangaroo court of the Cochise County jail, having jurisdiction over all persons within its confines, is now in session." Prisoners removed their hats and formed a circle around the "judge." The new arrivals were read the "revised statutes" of the court and were subject to Rule No. 1, which stated that all persons entering this jail were subject to a fine of no less than $1. Del Lewis's many friends were saddened when they heard that he had died on December 31, 1911, after an operation to remove cancer of the tongue. (Courtesy Arizona Historical Society.)

Robert Hatch, born in 1842, served in the Union forces during the Civil War and arrived in Tombstone in 1880. He ran unopposed for Cochise County sheriff in 1884. He was ordered by the supervisors to "get a janitor to keep order in the courthouse for $50 a month." Florence Hamseth was hired as "janitrex." Hatch purchased five dozen hand grenades for the protection of county buildings. A sub-jail was constructed in Bisbee and A. Barnaby was paid $4 for candles to light it. On October 6, 1885, Sheriff Robert Hatch offered a $500 reward for the capture of Geronimo, dead or alive. Also, Virgil Earp gave Hatch power of attorney to settle his mining claims. Hatch went on to become assistant superintendent at the Yuma Territorial Prison. He died at Fort Yuma on June 3, 1904. (Courtesy Arizona Historical Society.)

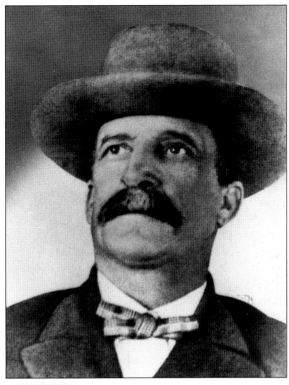

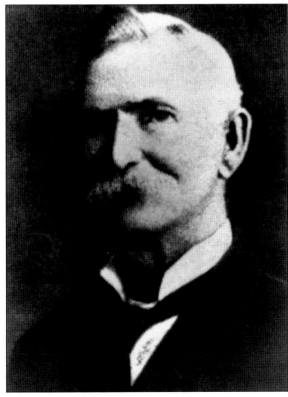

Sheriff Carlton B. Kelton was born in Baltimore, Maryland, on July 8, 1839, and served as a Confederate captain during the Civil War. He fought with Gen. Robert E. Lee at Manassas. On May 7, 1879, Kelton left Washington D.C. with a party of 11 men under Major Hall for Arizona and reached Tombstone in the latter part of June. He served as a customs collector at Lochiel, a deputy U.S. Marshal, and a mounted border patrol inspector. Kelton, a big kind-hearted man, permitted his prisoners to exercise in the jail yard—a few even exercised themselves right over the prison walls! After serving as sheriff, he was elected to the Territorial Legislature. After this term, Kelton moved to Virginia and lived in an Elks Home. On October 8, 1925, he was found dead on a train at Greenville, Alabama. He was on his way back to Arizona for a pioneers' reunion. (Courtesy Arizona Historical Society.)

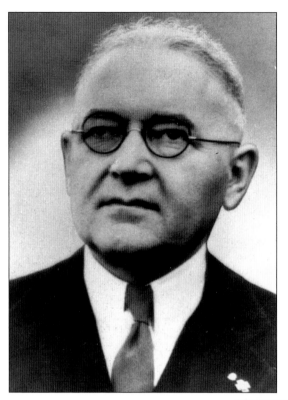

Deputy Sheriff Guy C. Welsch was appointed to fill out Harry Wheeler's term when Wheeler went off to war. Guy Crittenden Welsch, born at Greeley, Colorado, on April 15, 1879, attended the State Normal School at Greeley. He worked in a store and joined a surveying party before serving in the Spanish-American War. After the war, he remained in Manilla with the American Commercial Company for five years. He returned to the United States and was employed by a Seattle lumber company in 1905. Shortly after Welsch took office, Fred Koch shot and mortally wounded T.R. Brandt, cashier of Tombstone's First National Bank, who had refused to give him "all the money in sight." Koch became frightened and fled without taking any money. Welsch organized a posse and captured Koch after the posse directed a number of bullets in the direction of the fugitive. (Courtesy Arizona Historical Society.)

Sheriff Joseph E. Hood, born February 14, 1880 in Nutrioso, Arizona, was an assistant postmaster and worked for the U.S. Customs Service. Hood's most famous case involved the robbery of the Bisbee Post Office in 1921. When the janitor, Simon Escabedo, went to work the evening of April 5, he found an empty vault and Postmaster Lon Bailey tied to a chair and gagged, his face beaten. Bailey gave Deputy Vernon La More and Hood detailed descriptions of two men, who he said beat him and took about $42,000 from the vault. Post office inspectors could not find anyone fitting Bailey's description. On April 17, federal detectives advised Hood that they were going to arrest Bailey. After some pressure, Bailey indicated he was ready to talk. He ended up serving a sentence at Leavenworth. Joseph E. Hood died on August 25, 1960, at 80, in Kingman, Arizona, where he had been a successful rancher. (Courtesy Arizona Historical Society.)

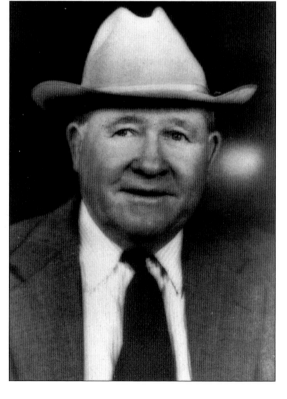

Sheriff George Henshaw was born in 1879 in Phoenix and came to Cochise County in 1900. Before going to work as a deputy sheriff, Henshaw worked as a bookkeeper for the Cananea Consolidated Copper Company in Mexico. Henshaw always contended that the automobile put added strain on lawmen, because criminals could get away quicker and go farther, and cattle rustlers could use trucks instead of horses. In 1929 Mexico was in the throes of a revolution and weekend visitors swarmed over the border to collect souvenirs off the dead. When several spectators were killed, Henshaw swore in extra deputies to keep the curious out of bullet range. During Henshaw's tenure, Deputy Sheriff Charles Bradley was shot by John Lyall of Tombstone on October 14, 1929. Bradley had arrested Lyall for stealing cattle. Lyall was found guilty, but the Arizona Supreme Court reversed the decision. Lyall then swore out a warrant charging that Bradley had perjured himself when he claimed his name was Bradley when really it was McNally. Bradley was ordered to come to Benson by private conveyance and Lyall was told to stay in Tombstone. However, Bradley met Lyall in Tombstone. Seven shots were fired by the two men who were never more than four feet apart. A bullet hit Bradley in the stomach. Tombstone chief of police Pugh placed Lyall under arrest. (Courtesy Arizona Historical Society.)

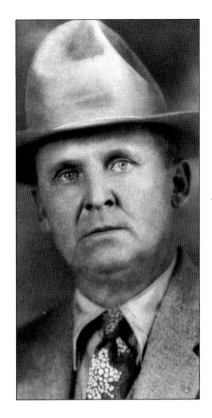

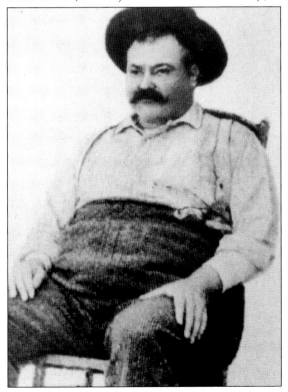

Fatty Ryan, a native of Ireland, served as a colorful Tombstone chief of police. He was in Virginia City at the time of its boom and in 1880 left Nevada for Tombstone. He was also a member of the fire department and owned the Exchange Saloon in Bisbee. He would open a gambling game with a gold piece on top of a stack of lead. While in Bisbee in December of 1898 Fatty caught a cold that turned into pneumonia. At his funeral in Boothill, attorney Allen English said, "Fatty old boy, rest in peace. In these days, King is high and Ace is low." (Author's collection.)

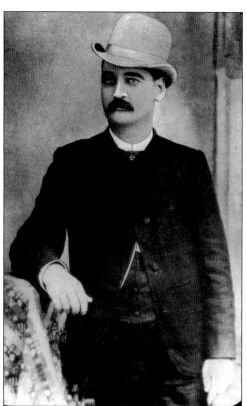

William Barclay "Bat" Masterson, a gunfighter, gambler, and sports writer, met the Earps in Dodge City and remained their lifelong friend. Barclay took a train to Trinidad, Colorado, where he boarded the new Santa Fe Line. This train consisted of a caboose and an engine. When the train dropped off its few passengers, they embarked on an overland coach. Because Bat Masterson carried a Sharps rifle and two Colt revolvers, it was agreed that he should ride shotgun next to the driver. Masterson took the train from Deming, New Mexico, to Benson where he caught a stage to Tombstone. Bat was soon in charge of keeping the peace at the Oriental. Trouble surfaced between Bat and another gunfighter, Luke Short. (Author's collection.)

In the early morning hours of February 25, 1881, Luke Short got into an altercation with Charlie Storms at the gaming tables. Bat Masterson took Storms to his room but Storms lacked the good sense to stay there. He went back out onto the street and confronted Masterson as he was trying to talk sense into Short. After listening to a few deprecatory words from Storms, Short stuck the muzzle of his gun into Storms heart and pulled the trigger. Short died of dropsy in 1893 at Guedo Springs at 39. (Courtesy Ben Traywick.)

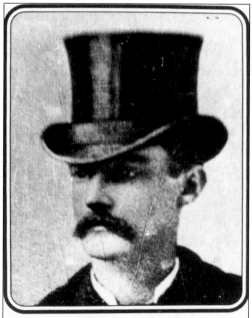

LUKE SHORT
Died 1893 of dropsy in Geuda Springs, Kansas.

Buckskin Frank Leslie was known in Tombstone as a big windy, of whom little could be believed. In 1880 he became romantically involved with the wife of Mike Kileen. At a confrontation in the Cosmopolitan Hotel, Leslie shot it out with Kileen; shortly thereafter Leslie married Kileen's widow. After accusing him of beating her, she divorced Leslie. In 1889, after a liquor-soaked weekend, Leslie shot and killed his paramour Mollie Williams and wounded a ranch hand, James Neal. He tried to blame the shooting on Neal, but a jury thought otherwise and sent him to the Yuma Hellhole, as the Yuma Territorial Prison was affectionately known. He was pardoned in 1896 and went to California where he took up with old-time Tombstoners, who gave him odd jobs and spare clothes. Before long he disappeared from the annals of Tombstone history. (Courtesy Ben Traywick.)

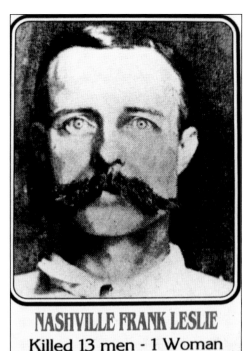

NASHVILLE FRANK LESLIE
Killed 13 men - 1 Woman
Disappeared.

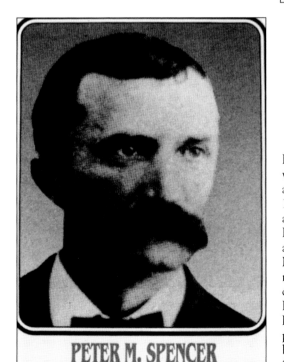

PETER M. SPENCER
Died 1914, vicinity
Globe, Arizona, A.T.

Peter Spencer, also known as Peter Spence, was really Elliott Larkin Ferguson, an all-around bad guy born in Texas around 1842. He came to Arizona around 1878 and may have robbed a mail rider near Prescott. He was also accused of robbing a stage near in Benson in 1881. His wife, Maria Duarte, implicated him in the murder of Morgan Earp. None of these charges stuck. He ended up in the Yuma Hellhole, convicted of the murder of Rodney O'Hara, but Gov. Joseph Kibbey pardoned him in 1894. Spencer served briefly as a deputy sheriff in New Mexico. On April 2, 1910, he married Phin Clanton's widow, Laura Jane. Pete died of pneumonia near Globe on January 30, 1914. (Courtesy Ben Traywick.)

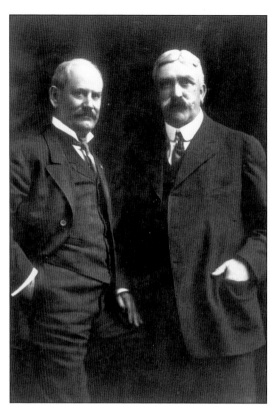

Frank Cox and Marcus Aurelius Smith were colorful attorneys who argued with each other and drank together. Both men had extensive mining interests. Smith, born in Kentucky in 1852, received a law degree from Kentucky University and became a city attorney for Lexington. He went west and became ill in Tombstone. He was so touched by the kindness of the people that he moved West in 1880. He also defended Frank Leslie in what may have been his most difficult case because a man who killed a woman was considered unworthy of life in Arizona. He was elected district attorney of Cochise County and ultimately became a delegate to Congress. Marcus Aurelius Smith died in 1924. (Courtesy Arizona Historical Society.)

Attorney Allen Robert English, born in Michigan in 1858, arrived in Tombstone in 1880. He served as Tombstone's justice of the peace, and Cochise County district attorney. A big man with a rich, sonorous voice, his courtroom arguments went on for hours, spiced with Latin phrases and quotations from Shakespeare. English and a few tipplers were in a bar arguing about whether or not it was going to rain on June 24, San Juan's Day. English said if it rains, "I'll strip naked and stand under that water spout." There was a downpour on June 24, and Allen English, stark naked, stepped outside of King's Saloon and stood under the water spout. When he did not get an appointment as U.S. district attorney for Arizona Territory, he inquired why. English was told his application contained a picture of him standing naked under the water spout with a note which read, "This is the man you are considering for U.S. District Attorney?" (Author's collection.)

Seven

TOMBSTONE'S BOOTHILL CEMETERY

Probably no cemetery gives visitors such an enthusiastic welcome as Tombstone's Boothill Cemetery. Almost any day of the year one can find a horde of tourists photographing, laughing, and shaking their heads over the grave markers. Here, Tombstone residents, who died with their boots off (natural causes) and boots on (murdered) rest together in their final sleep in a six-by-three-foot plot. The Tombstone cemetery was laid out in 1878. It eventually became Boothill, covered with desert shrubs and salty epithets, on a rocky hillside facing the Dragoon Mountains. The "better" class of Tombstone residents soon became disturbed at the thought of being interred with gamblers, prostitutes, and murderers, so they secured a plot of ground for a second cemetery, but no one goes there. About 250 people are buried in Boothill, but unfortunately many of the graves are marked simply "unknown." The last man to be buried in Tombstone's Boothill was Glen Will, also known as Bronco Bill. He had been in Tombstone as a youth and always wanted to go back, so his son sent his ashes "C.O.D." and Tombstone buried him in Boothill in 1953.

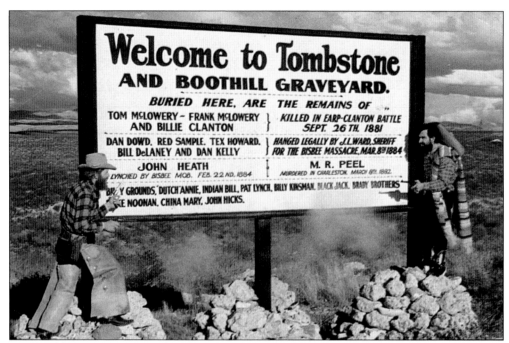

Nothing like a rootin' tootin' shoot-out out between friends. Note that the sign has several names misspelled. Heath should be Heith and McLowery should be McLaury. (Author's collection.)

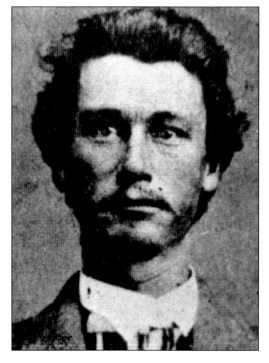

John Hicks, the first person to be buried in Boothill Cemetery, was shot down in front of Sam Danner's Saloon in 1879. Hicks appears to have been a fairly honest, industrious miner, and why he was shot down is not quite clear. Some say it was over a woman in the red light district, while others claim he was trying to help a man by the name of Quinn, when Jeremiah McCormick shot him through the back of the head with a revolver. During the shootout, John's brother Boyce Hicks was wounded and blinded for life. A carpenter made a coffin and lined it with canvas. Davis Chamberlain provided a white shirt, probably the only one in the camp, to put on Hicks. If Jeremiah McCormick was the man that killed Hicks, he was never apprehended. (Courtesy Ben Traywick.)

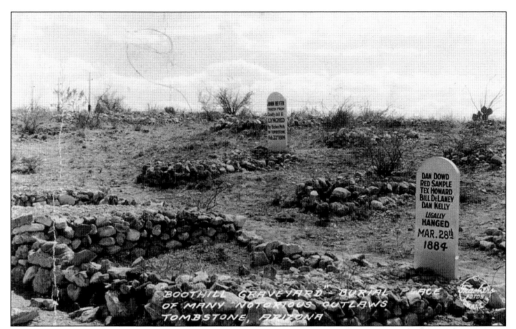

In the foreground Dan Dowd, Red Sample, Tex Howard, Bill Delaney, and Dan Kelly share a common headstone. They were "legally" hanged by Sheriff Jerome Ward for the murder of Anna Roberts during the robbery of the Goldwater and Castaneda store in Bisbee, Arizona. The store's owner, Joe Goldwater, is an ancestor of Senator Barry Goldwater, who served Arizona for many years and also ran for president. (Author's collection.)

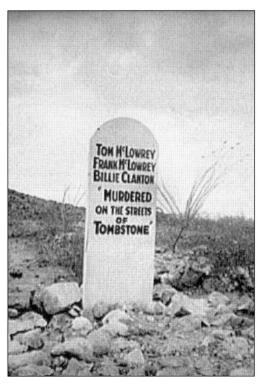

While the Earps and Holliday contended that the gunfight at the O.K. Corral was a discharge of official duty, the McLaury and Clanton kin did not see it that way. They contended that the deceased had been murdered on the streets of Tombstone. Tom and Frank rode to Boothill in one hearse while Billie rode alone in another hearse. The three men were interred in a common grave. The funeral took place at Ritter and Ryan undertakers, and the procession to the cemetery was led by the Tombstone Brass Band. (Author's collection.)

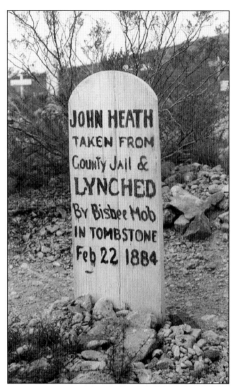

John Heith (sometimes spelled Heath) was taken from the Cochise County Jail and lynched by a Bisbee mob in Tombstone. When the people of Tombstone awoke the next morning, they found a note attached to Heith's body that read, "John Heith was hanged to the pole by the citizens of Cochise County, for participation as a known accessory in the Bisbee Massacre at 8:20 a.m., February 22, 1884." A coroner's report read, "We the undersigned, a jury of inquest, find that John Heith came to his death from emphysema of the lungs—a disease common in high altitudes—which might have been caused by strangulation, self-inflicted or otherwise." (Author's collection.)

Omar W. "Red" Sample, Jack "Tex" Howard, Dan Dowd, W.E. "Bill" Delaney, and Dan Kelly were each escorted by a complement of priests and deputies and Sheriff Jerome Ward to the gallows at noon on March 8, 1884. The previous evening each man had an oyster dinner with their requested dessert, and the county gave each prisoner a new suit of clothes. When they had the nooses adjusted, each man was asked for last words. Dowd said, "This is a regular choking machine," and Kelly said, "Let her go!" When Sheriff Ward asked Sample, Delaney, and Howard if they had anything to say, they each answered "No." After the doctor pronounced the five outlaws dead, their bodies were put in rough plank coffins and buried a common grave in Boothill. (Courtesy Library of Congress.)

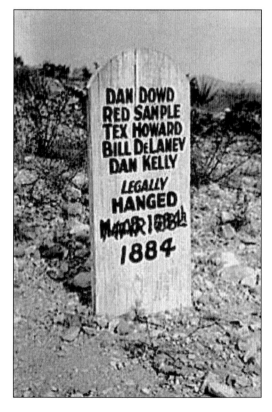

Little Gertie, also known as Gold Dollar, caught her man Billy Milgreen cheating on her with a new girl known only as Margarita. When she caught Margarita flirting with Billy, Gold Dollar pulled out a handful of Margarita's hair. Margarita fought back, but Gold Dollar pulled a wicked knife from her garter and stabbed Margarita, who fell onto a poker table and bled to death. No action was taken against Gold Dollar, who quickly disappeared from the Tombstone houses of ill fame. (Courtesy Ben Traywick.)

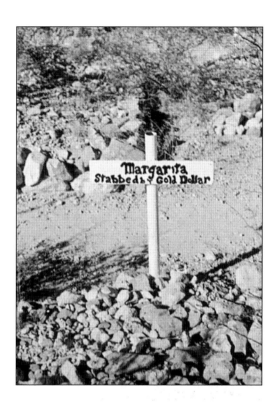

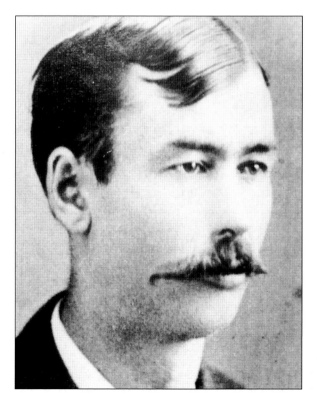

Margarita and Gold Dollar fought over Billy Milgreen, a local gambler at the Bird Cage. Gold Dollar lived with Milgreen and considered him her man. That was okay until the tall sultry Margarita came to town and began competing for Billy's affections. Billy promised to have nothing to do with Margarita but Gold Dollar did not altogether trust him. (Courtesy Ben Traywick.)

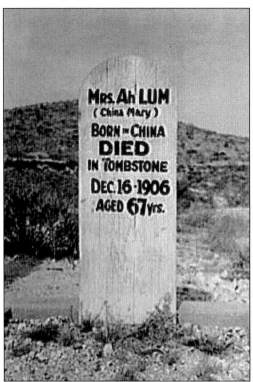

China Mary was probably a member of the famous San Francisco Six Company, which distributed the Chinese all over the West. One could feel quite confident hiring a cook or housekeeper from China Mary. She would say, "Him steal, me pay. Him no steal." If the Chinese worker did steal or became in any way offensive, China Mary would run him out of town, and with a smile on her face, she would say, "All right, him leave right away." (Courtesy Library of Congress.)

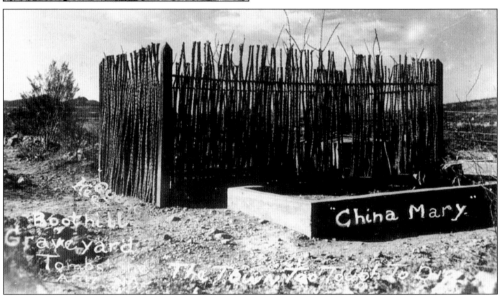

What set China Mary apart was her generosity to those down on their luck. When a cowboy named Andy Darnell broke his leg in a fall from his horse, he was going to be taken to a hospital. China Mary insisted that she would pay for him to be cared for in Mary Tack's rooming house. As she aged, she joked that it was time for her to go back to China where her parents had arranged a marriage for her. Now she had to finish the job. She never got a chance to finish the job but died in Tombstone, and a large number of people came to pay final respects when she was buried in the Chinese section of Boothill. (Author's collection.)

George Johnson was hanged by mistake. In fact, Johnson was not only hanged for a crime he did not commit—he was hanged for a crime that was never committed! George, lazy but harmless, acquired a pair of six-guns and decided to embark on an outlaw career in October 1882. While trying to hold up a stage his horse shied and Johnson's gun went off. A passenger, Mr. Kellogg, slumped to the ground and the driver put Mrs. Kellogg on a horse to get the sheriff. The driver captured Johnson just outside Tombstone, where Mrs. Kellogg told everyone how Johnson had shot her husband in cold blood. Mr. Kellogg had not been shot but had died of a heart attack. However, the angry mob decided to have a necktie party in Johnson's honor. Before dancing the dead man's jig, Johnson told the crowd that he had killed several men and only wanted a decent funeral. (Author's collection.)

John Blair, a member of the Double Dobe Outlaw gang, contracted smallpox, a fearful scourge on the frontier. His friends isolated him in a cabin where he was cared for by a woman who already had smallpox. When he died, his friends had to decide how to bury him without coming in contact with the disease themselves. They decided to tie a rope around his feet and drag him into a hastily dug grave in Boothill. (Author's collection.)

Mike Kileen was shot and killed by "Buckskin" Frank Leslie in June 1880. (Frontier markers never went through spell check.) Mary Kileen, an Allen Street girl, was estranged from her husband, Mike Kileen, a bartender at the Palace Saloon. She had gone to a dance with Leslie and they were sitting on the porch at the Cosmopolitan when Mike tried to sneak up on them to kill either Leslie or both. Mike inflicted a minor abrasion on Leslie's head, but Leslie shot Mike in the chest and face. Mike Kileen lingered for a few days before joining the sleep of Boothill. (Courtesy Ben Traywick.)

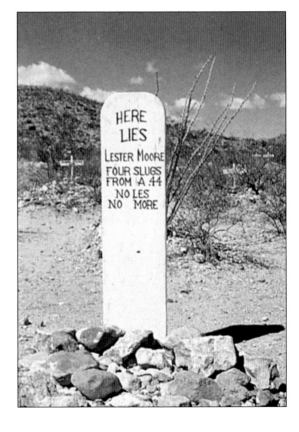

Lester Moore worked as Wells Fargo Stage agent in Naco. When Harry Dunstan arrived to claim a package, he found it badly damaged. After an argument, both men went for their guns and in a blaze of gunfire, Moore fell with four slugs from a .44. Dunstan also died from just one of Moore's shots. Moore, an innocuous man, became world famous with his epitaph. (Courtesy Ben Traywick.)

On March 26, 1882, Messrs. Austin Cheney, Hunt, and M. Robert Peel, while sitting in the office of the Tombstone Mill and Mining Company, were killed in what the *Epitaph* described as "Murder Most Foul." Peel's father, Judge B.L. Peel, had an office in Tombstone. Outlaws broke into the office and shot Peel at such close range that his clothes caught fire. The other men had a chance to drop and escaped the shots. The masked murderers, William Grounds and Zwing Hunt, had a long history as troublemakers and died in a shootout without going to trial. (Courtesy Ben Traywick.)

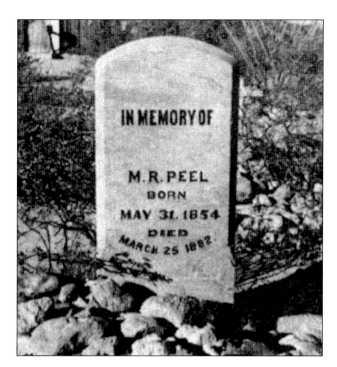

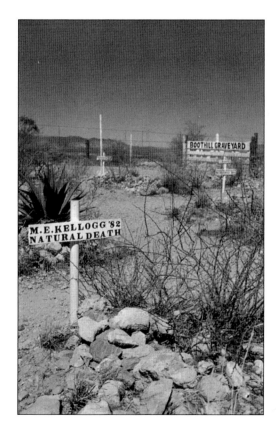

M.E. Kellogg's epitaph of "Natural Death" is not entirely true. Kellogg died of a heart attack when George Johnson tried to hold up a stagecoach on which Kellogg was a passenger. (Author's collection.)

101

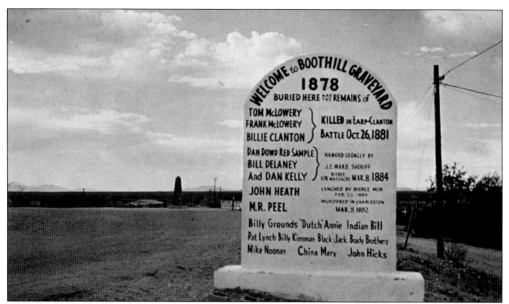

This is another example of a generous welcome listing the distinguished residents of Boothill. Mike Noonan, better known as Crazy Mike, built his ranch in the middle of Apache lands. Whenever they approached, he would roll his eyes and loll on the ground like a crazy man. Because the Apaches believed that those whom the gods drove mad were special, they left him alone. This worked until they caught onto his ploy and, one day, they shot him dead. Sy Bryant and Sam Coleman found Noonan's body and brought it to Boothill for burial. (Author's collection.)

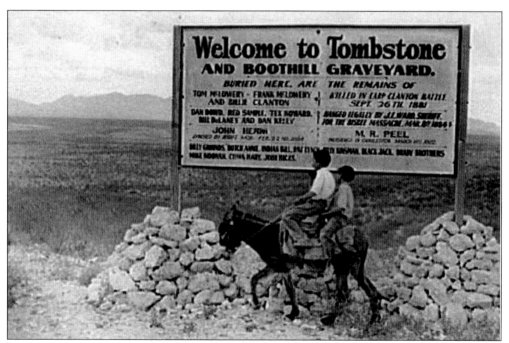

In the 1940s, the U.S. War Department hired photographers to take pictures of various sites. The famous photographer Dorothea Lange captured these young men on a casual ride past Boothill's entrance. (Courtesy Library of Congress.)

Eight

HELLDORADO

Billy Breakenridge was fond of saying that men came to Tombstone to find El Dorado but all they found was Helldorado. The mines filled with water, the demonetization of silver passed, and Tombstone was fast becoming a ghost town. When Breakenridge published his book, *Helldorado*, in 1928, Tombstone once again attracted national attention. The town with a bank of memories polished up its gunfighter image and became an important tourist attraction. In 1929 the first annual Helldorado Days celebration was held. All the living pioneers who could make the journey visited the town. The brochure alleged that "at least one dead man was provided for breakfast every morning." Daily there was a stage holdup and the men wore enough guns and ammunition to start a small war. The Bird Cage came to life with old time revues and plenty of whiskey. The highlight was the re-enactment of the gunfight at the O.K. Corral. Old-timer John Clum insisted that Tombstone did not deserve this lurid representation—but it was a hit with the tourists. Tombstone became "The Town Too Tough to Die." The Cochise County seat was moved from Tombstone on December 2, 1929 to Bisbee, and all the town had was its history. Luckily, that proved to be a bonanza.

William "Billy" Breakenridge served as a deputy sheriff under Cochise County Sheriff Johnny Behan during the O.K. Corral gunfight. His book *Helldorado* was a scathing indictment of the Earps and Doc Holliday. The book title also gave the name to the annual Tombstone celebration of its history. Breakenridge had known many of the Tombstone bad guys including Zwing Hunt and Billy Grounds. (Author's collection.)

John Clum, former editor of the *Epitaph*, returned from Los Angeles to ride in the first Helldorado parade. Clum, a friend of the Earps, was disappointed by the celebration in that it painted a grisly picture of Tombstone's history. Clum later wrote that although criminals and crime existed in Tombstone, dissipation, disorder, lawlessness, and murder were not the chief occupations of the citizens of Tombstone. (Courtesy Ben Traywick.)

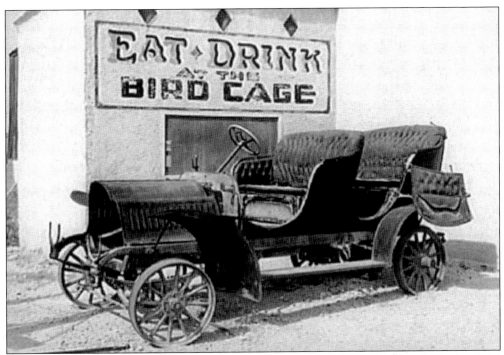

The Bird Cage is by now well past its lusty prime, but an old touring car still stops by to eat and drink. (Courtesy Library of Congress.)

Traces of murals decorating the exterior of the cribs at the Bird Cage still remain, but the voices of revelers and dancing girls are long gone. (Courtesy Library of Congress.)

The Bird Cage houses a safe and desk from an old mining company. Pictures of the characters and performers who frequented the Bird Cage are still very much in evidence. (Courtesy Library of Congress.)

Cracked adobe and broken dreams of instant riches are all that remain of the last miner's boarding house in Tombstone. (Courtesy Library of Congress.)

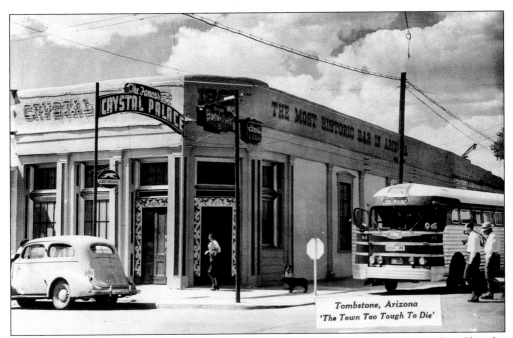

By the 1930s tourists were already arriving in buses. The Crystal Palace advertised itself as the most historic bar in Arizona. (Author's collection.)

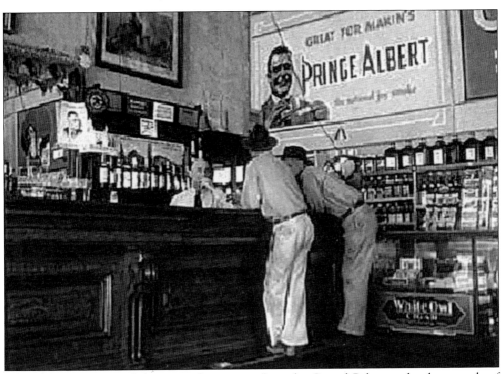

The gambling tables and dancing girls are gone from the Crystal Palace and only a couple of cowboys belly up to the bar for drinks and a chat with bartender. Prince Albert has the biggest advertisement in the establishment. (Photo by Dorothea Lange; courtesy Library of Congress.)

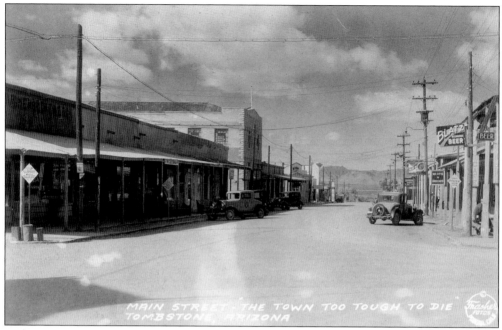

Only a few old cars remain on the once-bustling Allen Street, but Tombstone advertises itself as "The Town Too Tough to Die." Electric poles line the streets and the visitor can still find a cold one. (Author's collection.)

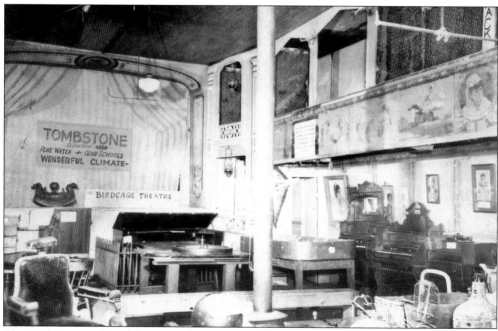

The Bird Cage and its infamous cribs are just a part of history, and the theater now serves as a storage space for old furniture. The sign advertises Tombstone as having pure water, good schools, and a wonderful climate. (Author's collection.)

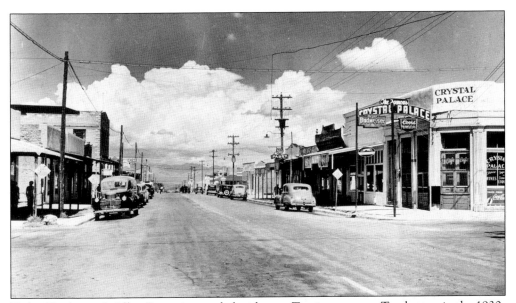

Today Tombstone's Allen Street is crowded with cars. Tourism came to Tombstone in the 1930s when Stuart Lake published Wyatt Earp's biography. At the left is the old covered boardwalk near the O.K. Corral. (Author's collection.)

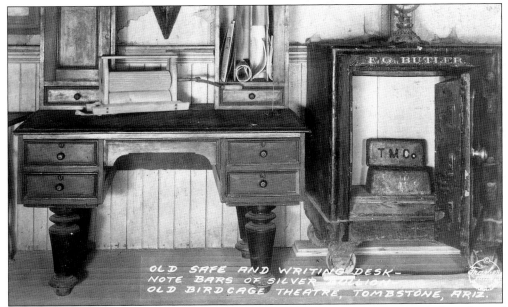

The E.G. Butler safe and old writing desk are stored in the Bird Cage. Two very large bars of silver stamped "T.M." for Tombstone Mining are in the safe. (Author's collection.)

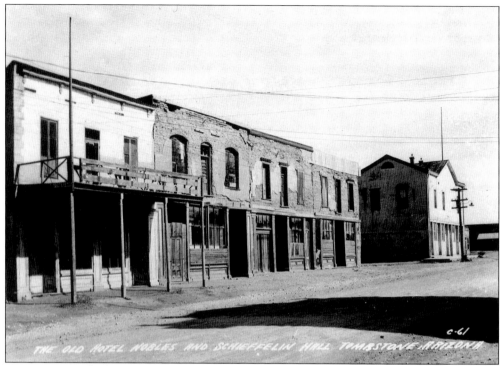

By the 1930s the once elegant Hotel Nobles was in shambles. Schieffelin Hall survives to the present day. (Author's collection.)

An old freight wagon, which was once full of rich silver ore and pulled by teams of mules, rests quietly in the shade of a tree, c. 1973. This wagon hauled ore from Tombstone to Bisbee and Tucson. (Author's collection.)

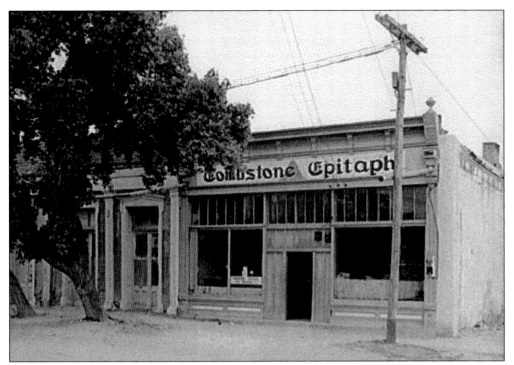

The Tombstone *Epitaph*, which reported the gunfights and other social news of Tombstone, is today housed in different quarters and reports the history of the West to its world-wide readership. (Author's collection.)

O. Homo was not a rancher, gambler, or a miner, but he belongs in Tombstone's history if only as a quirk—and there were plenty of them in Tombstone. O. Homo walked into Tombstone in the summer of 1891 stark naked except for sandals and a skull cap. Tombstone was a tolerant town, but not that tolerant. The judge sentenced him to 30 days in jail for indecent exposure. While O. Homo would eat only mud with a few mesquite leaves, he quoted the Bible and Shakespeare. No one ever discovered his true identity and he left Tombstone as mysteriously as he had arrived, never to be heard from again. (Author's collection.)

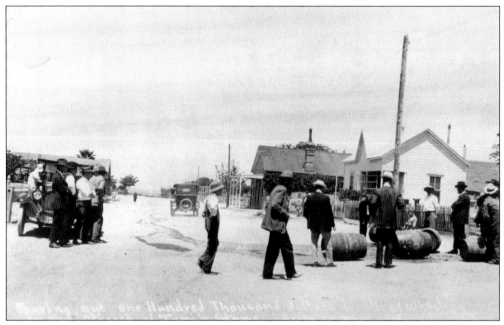

Prohibition took its toll on the Tombstone economy. Around 1918 the sheriff and his deputies destroyed more than 100,000 gallons of illegal whiskey, which had been stored in the courthouse. The barrels were punctured and the liquor was allowed to run down the dusty streets of Tombstone, giving a whole new meaning to phrase "The liquor flowed freely." (Author's collection.)

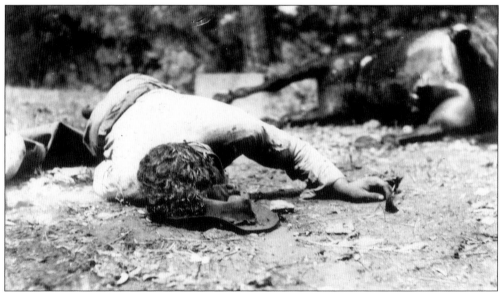

A local bootlegger and his horse found a lonely death in the Huachuca Mountains. (Courtesy Arizona Historical Society.)

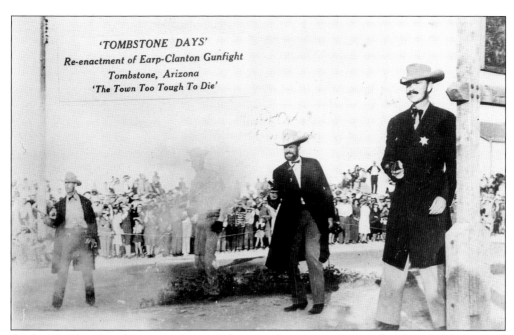

At this Helldorado celebration, the gunfighters are having much more fun than did the original participants. (Author's collection.)

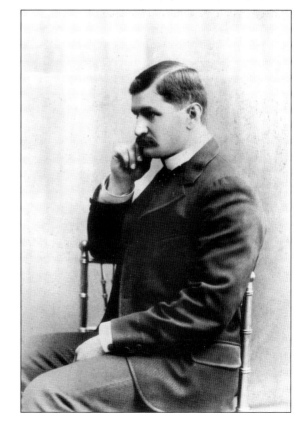

Anton Mazzanovich, who published extensively on Apache wars, participated in the first Helldorado celebration. After working in southern Arizona mines he went to Hollywood where he enjoyed success as an action star and a singer. He became known as Tony Dalton, the singing cowboy. (Courtesy University of Arizona Special Collections.)

The late "Red" Marie Traywick helped form Tombstone's Hell's Belles, who put on dancing girl performances during the annual Helldorado days celebration. (Courtesy Ben Traywick.)

The 1993 Hell's Belles look as though they could give Dutch Annie's girls a run for their money. (Courtesy Ben Traywick.)

Ed Wien and Ed Smith were a couple of Benson cowboys who enjoyed golf and trained their horses to act as caddies. They built a three-hole golf course near Russelville, not far from Tombstone, which some unkind souls called a massive sand trap. The times were changing but southern Arizona cowboys still carried firearms. (Author's collection.)

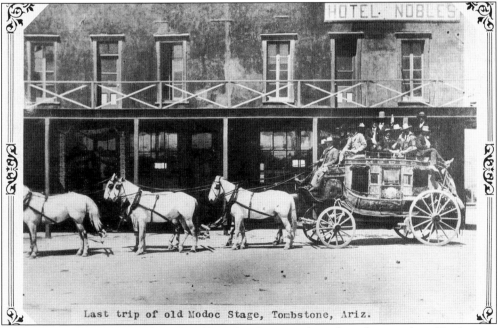

Last trip of old Modoc Stage, Tombstone, Ariz.

During the first Helldorado days the old Modoc Stagecoach made its last trip from Tombstone. It picked up a load of passengers in front of the Hotel Nobles and waited while everyone got their picture taken. (Author's collection.)

George Chambers and the late Senator Barry Goldwater saved much of Tombstone's history when the Cochise County Courthouse moved from Tombstone to Bisbee. The movers dumped many of the records down a mine shaft. Chambers and Goldwater retrieved the records and brought them to the Arizona Historical Society in Tucson and the Arizona State Archives in Phoenix. (Courtesy Arizona Historical Society.)

Tombstone's official historian, Ben Traywick, generously shared his pictures and information with the author on this project. (Courtesy Ben Traywick.)

Nine

TOMBSTONE AND THE MOVIES

Tombstone has been the subject of dozens of movies, two prime-time television shows and countless comic books and western novels. The most important movies include *Law and Order* (1932) with Walter Huston as a Wyatt Earp–like character; *Frontier Marshal* (1934) with George O'Brien as Earp; a second *Frontier Marshal* (1939) with Randolph Scott as Earp and Cesar Romero as John "Doc" Holliday; *Tombstone: The Town Too Tough to Die* (1942) with Richard Dix; *My Darling Clementine* (1946) with Linda Darnell, Victor Mature, and Henry Fonda; *Gunfight at the O.K. Corral* (1957) with Burt Lancaster as Earp and Kirk Douglas as Holliday; *Hour of the Gun* (1967) with James Garner as Earp and Jason Robards as Holliday; *Doc* (1971) with Harris Yulin as Earp and Stacy Keach as Holliday; *Tombstone* (1993) with Kurt Russell as Earp and Val Kilmer as Holliday; and *Wyatt Earp* (1994) with Kevin Costner as Earp and Dennis Quaid as Holliday. In 1968 there was a Star Trek episode based on the gunfight at the O.K. Corral called "Spectre of the Gun." Who above a certain age can forget "Whistle Me Up a Memory," the lilting theme song of *Tombstone Territory* starring Pat Conway? Later on there was *The Life and Legend of Wyatt Earp* starring Hugh O'Brian.

Pat Conway, who played Sheriff Clay Hollister on *Tombstone Territory*, was born January 9, 1931, and died April 24, 1981, in Los Angeles. He was the son of director Jack Conway and grandson of the famous silent-era movie star Francis X. Bushman. The show ran from October 16, 1957, to September 17, 1958. The *Tombstone Territory* theme song, "Whistle Me Up A Memory" was written by William M. Backer, who also had other hits such as Coca Cola's "I'd Like to Teach the World to Sing." The cast included Pat Conway as Sheriff Clay Hollister; Gilman Rankin as Deputy Charlie Riggs; and Richard Eastham as Harris Claibourne, editor of the Tombstone *Epitaph*. (Author's collection.)

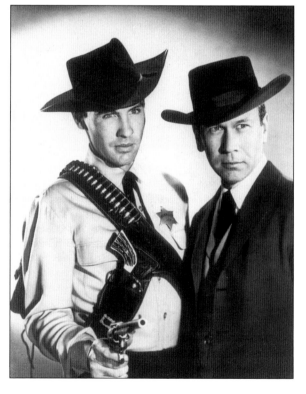

Pat Conway played Sheriff Clay Hollister; Richard Eastham portrayed Harris Claibourne, editor of the Tombstone *Epitaph*; and Gil Rankin played Deputy Charlie Riggs. Sheriff Clay Hollister defended the citizens of "The Town Too Tough to Die" from crimes reported in the *Epitaph*. Harris Claibourne, the newspaper editor, provided the background narration. (Author's collection.)

Hugh O'Brian starred in many television shows and movies, but he is most readily identified as the frontier lawman Wyatt Earp. He starred in *Life and Legend of Wyatt Earp*, which ran from 1955 to 1961. The show opened on September 6, 1955, and lasted four days longer than *Gunsmoke*. (Author's collection.)

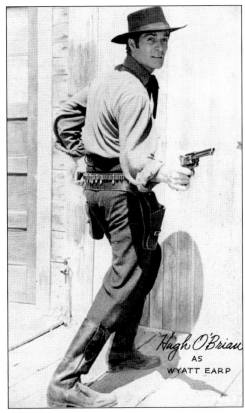

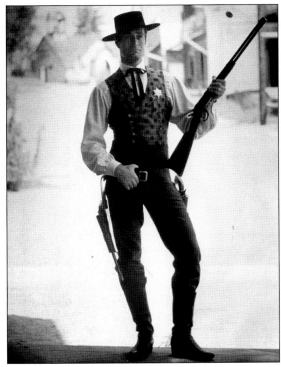

Actor Hugh O'Brian starred as Wyatt Earp for the entire series. In the first episode, "Mr. Earp Becomes a Marshal," Earp takes the job of a lawman after a friend had been gunned down. The theme song was "Wyatt Earp, Wyatt Earp / Brave, courageous, and bold / Long live his fame, and long live his glory / And long may his story be told." (Author's collection.)

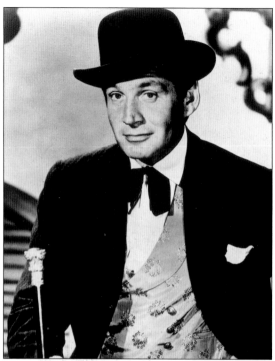

From October 8, 1959, to September 21, 1961, Gene Barry portrayed Bat Masterson on television. With a dapper derby hat, a gold-topped cane, and fancy clothes, this debonair ladies' man did not look like he belonged in Tombstone. However, that could also be said of the real Bat Masterson, a very close friend of Wyatt Earp. (Author's collection.)

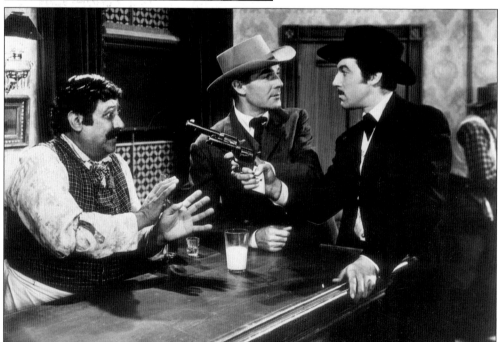

Frontier Marshal, starring Randolph Scott as Wyatt Earp and Cesar Romero as John Henry "Doc" Holliday, was one of the first movies to claim to be based on Stuart Lake's biography of Wyatt Earp. Here Wyatt is trying to talk the hot-headed Doc out of some sort of fight. The bartender wishes that they would just go away. Could that be a glass of milk on the bar? (Author's collection.)

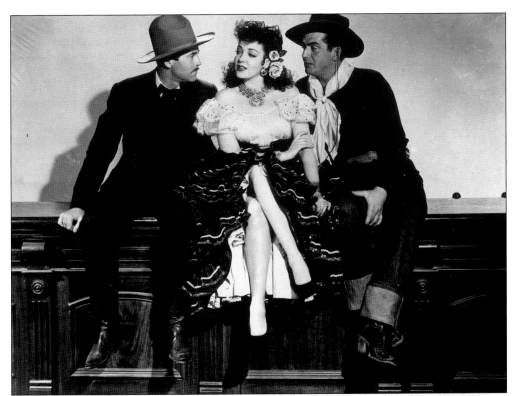

The 1946 movie My Darling Clementine also purported to be based on Stuart Lake's biography of Wyatt Earp. The stars included Henry Fonda, Linda Darnell, and Victor Mature. The most obvious discrepancy in the film is that there never was such a person as Clementine and the scenery shows the mountains of northern Arizona's Monument Valley. Director John Ford always was partial to Monument Valley for his films. (Author's collection.)

Henry Fonda portrays the life of the legendary Wyatt Earp, a drifter, a gambler, and a former lawman. Linda Darnell plays Chihuahua, a sultry dance hall girl, and Victor Mature plays Doc Holliday. Tombstone is a rough frontier mining camp with hell-raising saloons that wants to become a civilized, law-and-order community. Eddie Foy Jr. plays his father Eddie Foy, a traveling vaudeville performer. As Wyatt rides away, the school teacher, Clementine, waves a good-bye and a harmonica plays the tune "Oh My Darling Clementine." (Author's collection.)

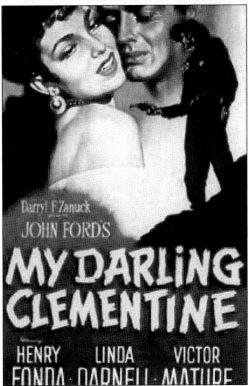

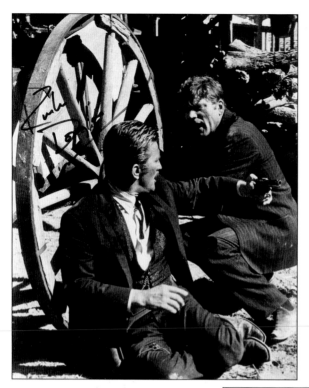

Burt Lancaster and Kirk Douglas put some great acting in *Gunfight at the O.K. Corral,* a rather mediocre movie. Novelist Leon Uris wrote the script for this movie based on the life and times of Wyatt Earp (Lancaster) and his sickly companion, Doc Holliday (Douglas). The action inevitably leads to the legendary battle between the Earps and Holliday against the Clantons and the McLaurys. Douglas played one of his best roles as the consumptive alcoholic Holliday. (Courtesy Old Tucson.)

Lancaster and Douglas show off their gun-totin' skills in an account of the events leading up to the famous gunfight, involving Wyatt Earp, his brothers, Doc Holliday as they battled the Clanton-McLaury cowboys. *Gunfight at the O.K. Corral* received Academy Award nominations for best film editing and best sound. (Author's collection.)

Even Star Trek got into the Tombstone act with "Spectre of the Gun" starring Ron Soble as Wyatt Earp along with Rex Holman, Charles Maxwell, Sam Gilman, and Ed McCready. In this episode Kirk and his crew find a ghostly town on an alien planet where everybody refers to the Enterprise group as the Clantons. Aliens force Kirk and company to re-fight the gunfight at the O.K. Corral. In one scene bullets pass harmlessly through Kirk and the others, and yet riddle a wooden fence behind them. (Author's collection.)

The punch line asks whether Wyatt Earp is a hero with a badge or a cold-blooded killer? Marshal Wyatt Earp kills a couple of men of the Clanton gang in a fight. In revenge Clanton's thugs kill the marshal's brother. The cast includes James Garner as Wyatt Earp, Tombstone's city marshal; Jason Robards as Doc Holliday; and Robert Ryan as Ike Clanton. (Author's collection.)

Five Guns to Tombstone, which had nothing to do with the original gunfight, starred James Brown, John Wilder, and Walter Coy. This oater is about ex-gunslinger Billy Wade (James Brown) who is approached by his outlaw brother Matt (Robert Karnes), just out of prison, to help him with a big-time robbery. Matt forces Billy to help, but Matt doesn't know that Billy is actually working for the law. (Author's collection.)

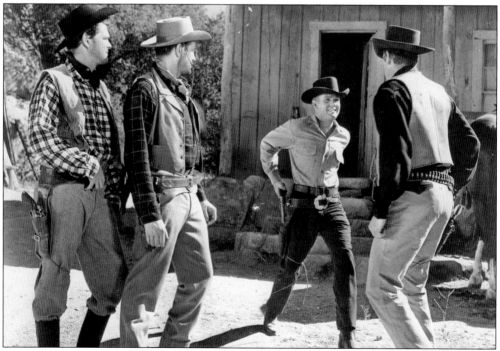

It is hard to see these men as bad guys. They seem to be having too much fun, or maybe they really are plotting a robbery. (Author's collection.)

Ten

LET'S VISIT
TOMBSTONE

And what does the visitor see in this historic town of Tombstone where so much western frontier history was made? The original Cochise Courthouse is now Arizona's smallest state park. Boothill, with its colorful epitaphs and miner's monument to Ed Schieffelin, is a must see. Downstairs at the Bird Cage visitors can see the auditorium that once presented some of the finest theatrical plays of the time in Tombstone and upstairs are the famous cribs. The Tombstone *Epitaph* still publishes Western history, and visitors are invited to come in and get information on events in town. Ron and Linda Tenney's bookstore has a fine selection of publications on Tombstone. St. Paul's Episcopal Church, first started by the Rev. Endicott Peabody, still has open doors. Stop in at Nellie Cashman's for cup of tea and piece of pie. These places, and more, have all been preserved.

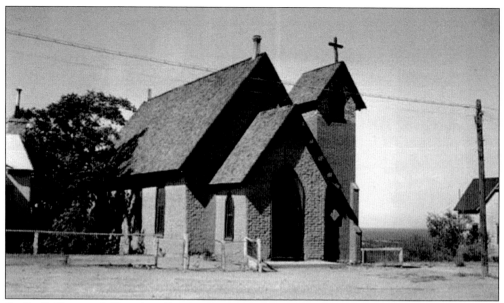

St. Paul's Episcopal Church still welcomes visitors. (Courtesy Groton School.)

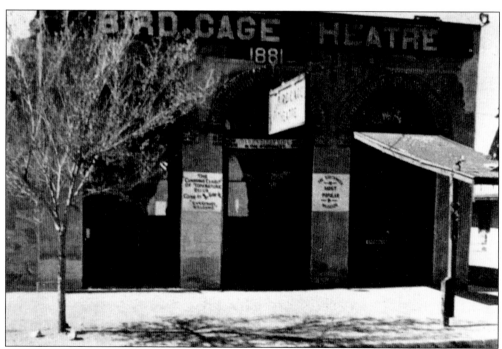

The Bird Cage Theatre has a gift shop for visitors. (Courtesy Ben Traywick.)

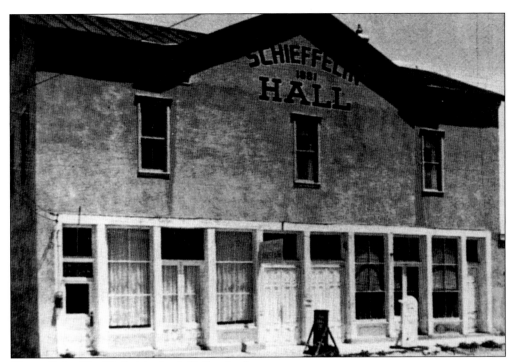

This is Schiefflin Hall. (Author's Collection)

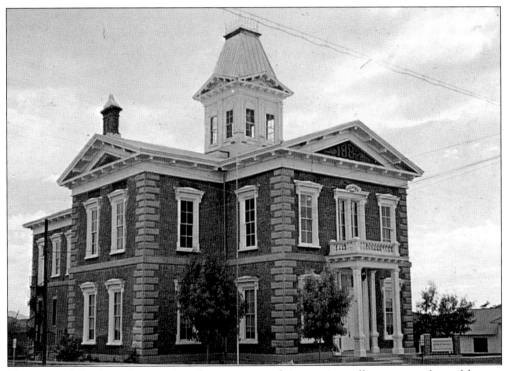

The original Cochise County Courthouse is one of Arizona's smallest state parks and houses hundreds of artifacts. (Author's collection.)

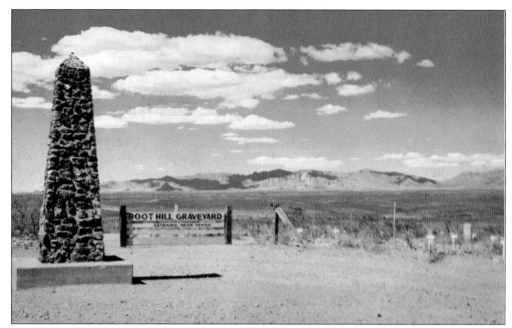

No trip to Tombstone would be complete without a visit to Boothill, seen here with Ed Schieffelin's monument. (Author's collection.)

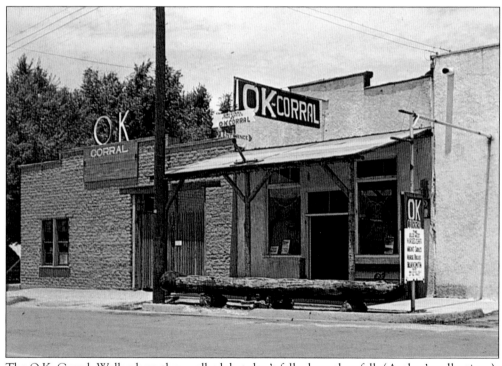

The O.K. Corral: Walk where they walked, but don't fall where they fell. (Author's collection.)